T0072317

UNTIMELY MEDITATIONS

THE MIT PRESS
CAMBRIDGE, MASSACHUSETTS
LONDON, ENGLAND

INCONSISTENCIES
MARCUS STEINWEG

TRANSLATED BY AMANDA DEMARCO

Originally published as *Inkonsistenzen* in the series *Fröhliche Wissenschaft* by Matthes & Seitz Berlin: © Matthes & Seitz Berlin Verlagsgesellschaft mbH, Berlin 2015. All rights reserved.

This book was set in PF Din Text Pro by Toppan Best-set Premedia Limited.

Library of Congress Cataloging-in-Publication Data

Names: Steinweg, Marcus, 1971- author. | DeMarco, Amanda, translator.
Title: Inconsistencies / Marcus Steinweg ; translated by Amanda DeMarco.
Other titles: Inkonsistenzen. English
Description: Cambridge, MA : The MIT Press, 2017. | Series: Untimely meditations | Includes bibliographical references.
Identifiers: LCCN 2017009920 | ISBN 9780262534352 (pbk. : alk. paper)
Subjects: LCSH: Inconsistency (Logic) | Philosophy, German--21st century.
Classification: LCC BC199.I45 S7413 2017 | DDC 193--dc23 LC record available at https://lccn.loc.gov/2017009920

Le plus beau serait de penser dans une forme qu'on aurait inventée.
—**Paul Valéry**

CONTENTS

play because no thought is firmly grounded.[2] The fathom-lessness of thought perforates the subject by inscribing an irreducible contingency within it. It sets it on the path of coincidence, which it attempts to answer with provisional consistency. Each of these attempts at consistency is indebted to engagements with ontological-mathematical inconsistency, which as Daniel Heller-Roazen writes, the Pythagoreans defined as unspeakable (*arrhetoi*), irrational (*alogoi*), or incommensurable (*asummetroi*).[3] When confronted with its own fathomlessness, logos becomes playful. You could say that it emancipates itself from myth by integrating myth's ludic qualities into itself. The logification of myth cannot be logified. It arises from a game that it simultaneously opposes. Nietzsche is just one example of this conflict. He stands at the beginning of logos-metaphysics' impossible end. His undertaking consists in showing metaphysics its own inconsistency by playing with it. "Perhaps," said Bataille, he "didn't completely abstain from philosophy, but he definitely passed over the opportunity to become a philosopher, preferring to devote himself to writing, which allowed him to constantly play with what he wrote."[4] But it is a game that demands the utmost concentration from its player. "The game of thought demands such force and such rigor that in comparison the force and the rigor demanded by construction can give the impression of laxity. The free-floating acrobat is subject to stricter rules than a mason standing on solid ground."[5] Nietzsche's game with logos, metaphysics, and their conceptual culture reflects the game of a world without ultimate meaning: "He protests

MARCUS STEINWEG

against the fact that we assign a purpose to things and to the world. For him, the world has no purpose, and we have no choice but to laugh at that which is."[6] To laugh at the world as a game that pulls the ground out from under the subject, leaving it to float over the abyss of ontological inconsistency, is to play a game whose meaning remains suspended. "A person who is playing the game always finds the power to overcome those horrors that the game entails."[7] This is ultimately what Nietzsche calls *life*, actively partici- pating in a game whose meaning proves to be the impossi- bility of meaning.

ARCHÉ

By translating the ancient Greek word αρχή with the words *origin* and *command*, Giorgio Agamben makes the claim that "there is no αρχή for command—that is, logos ex nihilo—because the command itself is αρχή—or at least because it takes the place of the origin."[8] In this, Agamben approaches the ontological axiomatics of two philosophers whose thought culminates in the repudiation of a positively formulated origin (αρχή): Ludwig Wittgenstein and Jacques Derrida. In his notes titled *On Certainty*, Wittgenstein states, "It is so difficult to find the beginning. Or, better: it is difficult to begin at the beginning. And not try to go further back."[9] What Wittgenstein calls the *beginning* is logos (language or meaning), which assumes the position of the origin. To begin at the beginning doesn't mean going back to the abso- lute origin. Wittgenstein's late thoughts revolve around the

absent origin—the missing αρχή—in whose stead a sort of *assertion* arises that is the architecture of logos, and that Wittgenstein describes as a language game or form of life.[10] It is a construction perched over the abyss of ontological inconsistency. It generates the milieu of consistency that we call reality. But that means that reality is a groundless ground, an entity that itself is not grounded. Its grounding— the level of logos; the system of organization and reference that we call reality—remains groundless. The "origin" is without origin. This is why Derrida spoke of a "prosthesis of origin," which "must be believed all the same, whether believable or not."[11] Here he approaches the slogan from Wittgenstein's late work: "What I know, I believe."[12] In another proposition, Wittgenstein says, "The difficulty is to realize the groundlessness of our believing."[13] Can it be said that the thought of Wittgenstein, Derrida, and Agamben all share a structural homology in which the origin, the αρχή, appears as an element that cannot be made logical?

But that would mean that a certain floating and lightness is proper to thought. It indicates a logos that totters with precision. Would that be the logos of art and philosophy?

SELF-TRANSCENDENCE

Philosophy entails opening to the dimension of the exterior, which Jacques Lacan labeled the real. One could—along with Nietzsche as well as Deleuze and Félix Guattari— also speak of chaos. In any case, it's the experience of a

MARCUS STEINWEG

resistance that cannot be internalized, and that drives thought to its limits.[14] The experience of the limit implies that the thinking subject hazards self-transcendence. If there is a subject, then it is a subject of originary self-transcendence that knows itself to be affected by forces that traverse and codify its body of knowledge. In the act of thought, the subject identifies itself as a subject of the exterior in both senses, which allows it to return, sovereign, to the exterior because it is marked as contaminated by the exterior. The exterior is one name for the incommensurable, the ontological inconsistency of its world, the contingency and indifference of the real, which undermines every assertion of meaning. Perhaps one could speak of a philosophy of blindness. Blindness and insight—also a book title by Paul de Man—cooperate in thought that refuses to bow to established dispositives. By extending beyond what is known and accepted, it documents the experience of the fragmentary nature of its realities.

SEXUALITY

A long history—you could call it the history of *essentialism*—would have it that the subject known as the *human being* should behave according to its *nature*. *Become who you are* said Nietzsche before Michel Foucault spoke of *becoming the other*.[15] That is what humanism requires of us: that humans should be humane. When they aren't, they fall outside of their own self-understanding. But everybody knows that being inhumane is part of human behavior and

therefore our (factually nonexistent) "nature." *Natura = essentia.*[16] The appeal to nature is the ideological gesture par excellence. There is no fascism that is not also naturalism (just as there is no racism that isn't sexist). Maybe humane sexuality is distinguished from animalistic sexuality in that it is anti-essentialistic. Certain manners of engaging in "the type of relation [that] transgresses nature" can indicate an inhumane humanism.[17] In sex, the subject exceeds its natural disposition. It invents varieties of uselessness. Undoubtedly they are what constitute human beings' fascinating unnatural behavior: the use of the body against itself, the invention of erotic practices beyond the mechanics of procreation and reproduction, the construction of a metaphysical physicality that allows the mind to cooperate with all the senses at the limit of sense (or the Kantian *realm of the purpose*), and even with lust. The creativity of human sexuality effortlessly exceeds the limits of its own economy.[18] It is wasteful, contradictory, and contingent. In this way, it begets its own withdrawal from the logic of sense and purpose. It could be called playful and severe. In any case, no other animal is capable of anything like it: the enjoyment of itself and others in the experience of senselessness and loss of self.

SAMURAI

Deleuze said of Foucault that "his mere existence was enough to stop idiots from braying."[19] The two are united by

their belief in the power of intelligence. Fascism, racism, sexism, and oppression in general are the product of universal stupidity. You're not going to beat them at the level of opinion. Ideology perpetuates itself on the plateau of opinion because all thought is barred there since it demands disrupting doxa. You would have to attempt to demonstrate that fascism, racism, and sexism are the result of active nonthought—and not the expression of personal or collective views. It's an error in thinking made by people who do not think, as they place their nonthought in the service of a stupidity that sees its greatest enemy in intelligence.[20] Foucault—like Deleuze and Derrida—made a deadly weapon out of his intelligence, which is marked by the doubting of all dispositives and registers, concepts and ideologemes. That's why Paul Veyne recognized the samurai in him. His books aren't written "to gather readers of every stripe around a warm hearth. They aren't communicative and they aren't suitable for elevating their readers' spirits. They're written with the sword, with the saber of a samurai, of a man who is sober through and through, and infinitely cold-blooded and reserved."[21] The structuralist who didn't want to be a structuralist, as a samurai! The intelligence that opposes stupidity must be intelligence used against itself. It incessantly tests its instruments and means. It never stops doubting itself. Instead of sitting near the warm hearth, it distances itself from it. It is the hyperboreanism of thought, which Deleuze speaks of, along with Nietzsche. It implies the cold fever of martial intelligence.

"Foucault," said Deleuze, "fulfilled the function of philosophy as defined by Nietzsche: being bad for stupidity."[22] At another point he says, "He was trembling with violence."[23]

VIOLENCE

The violence of idealism lies in its denial of factual violence. There is no getting beyond violence; to deny that could be a definition of idealism. There are—to paraphrase Derrida—only *economies of violence*. Deconstruction reveals these economies. It insists on a moment of irreducible violence.[24] In *Of Grammatology*, *arché-trace* also means *arché-violence*. It is *différance* as the violence of disruption. It marks the impossibility of pure self-affection, self-presence, or self-identity as self-affection, self-presence, or self-identity.[25] Some sort of structural violence or difference is at work in all systems of the self. It prevents narcissistic closure, which is why it takes on the characteristics of an opening that reaches into the closed (into Heidegger's withdrawal/concealing or λήθη). Violence is opening into closure. In the experience of violence, the subject comes into contact with a fundamental aporia. Before we begin to denounce violence—and there are often good reasons to do so—we must think of it in terms of structural ontology, even if we approach the limits of ontology when talking about Heidegger and Derrida.[26] These limits are determined by the undecidability of presence and absence. The absence that is characteristic of presence corresponds to the difference or identity or structural violence at the heart of all irenicism. A

theory is progressive (or *leftist* in the strongest sense of the word) only in confrontation with the thought and immanent violence of its realities, rather than their idealistic exclusion. Niklas Luhmann once said that a certain "moral chilliness" was all it took to provoke Habermas.[27] Isn't that statement generally applicable? Doesn't ontology—in which I include the ontology-critical ontologies of Derrida and Adorno— also always demand a modicum of moral chilliness in order to see more clearly than morality can allow itself? A little thermodynamic discipline seems a prerequisite for any thought that risks taking a cold look at the inconsistent parts of reality. With *arché-violence*, Derrida demonstrated that idealism that avoids confrontation with difference or violence is the real source of violence. Combating physical violence means thinking with structural violence.[28] That only works if you're willing to abandon the position of the Beautiful Soul.

REALITY

As a multifaceted, codified milieu of consistency, reality is overdetermined and excessively complex. In the sphere of this overdetermination and excessive complexity, the subject moves among structures that orient its thought and behavior. And yet in moments of critical disorientation, the subject experiences the inconsistency of the contingent fabric of consistency that constitutes its reality. Philosophy only exists as the experience of porosity, which characterizes the system of facts. That is why it can forge no alliances

with facts, which doesn't mean that it denies or misjudges their power. Only philosophy does not exhaust itself demonstrating this nonmisjudgment; only philosophy does not exhaust itself with its analytic power. Any philosophy that does not exceed its knowledge is no philosophy at all.

TIGER

The fact that the human being "is no longer the signifier of sense" (in contrast to the "human being of humanism"), as Jean-Luc Nancy writes, means that we are not the owners and protagonists of a given meaning but instead wander along the abyss of meaninglessness—an abyss that is an opening that has no end.[29] In that sense, the animal known as the human being reaches into the infinite. It will even experience its end, which we call death, as endless. The endlessness of the end: this could be a description of life. Life that progresses from one opening to the next, traversing an infinite number of openings, like the performer or tiger at the circus that jumps through a burning hoop and knows, at the moment of the leap, that it will never end. They jump, experiencing the endlessness of time at a standstill, which they connect to the truth of their lives, evoking an opening without end.

DISTANCE

Thought that thinks of the distance that divides it from itself, as from reality—that would be the thinking of art. Thought

MARCUS STEINWEG

at the limit of thought, as of art. Measuring a distance that spans the space of any reflection, to which proflection also belongs, breathless haste or precise delirium, which pushes thought to the limits of its certainties. The distance that separates the subject from itself in order to prevent self-coincidence is the breathing room of thought, as long as by thought we understand the experience of the limit of thought as the test of nameless evidence.

STAGE

There is nothing beyond the theater because there is nothing beyond the stage.

VECTOR

Is it possible to imagine a mode of thought that is not a confirmation of itself? Thought that neither troubles nor transcends itself? The thought of identitary self-assurance within the fantasy of a stable self? I think that wouldn't be thinking at all. It would be nothing but the refusal to think. Refusal to affirm oneself as an outcast from oneself—a feverish vector that leads into the unknown.

INTEGRITY

What if integrity is the fantasy of every thought? Wouldn't you have to call thought the thing that resists this fantasy (and along with it, large parts of the history of philosophy

and forms of idealism that dominate it, including the idealism known as realism)? Thought resists and actively opposes it, by responding to the *ideal of purity* with the normality of the heterogeneous, hybrid, and foreign. Thought would then be an assertion of the impossibility of integrity, affirmation of encounters unmonitored by any self. That would make it primordial.

HEGEL

In order to reach for its exterior—that is, that point at which it is no longer at home and has no fixed self—the subject must turn against itself, stand up against what—out of thoughtlessness or convenience or strategic simplification—is known as its identity. Hegel doesn't allow us to substitute the construction known as identity for a fantasy of difference. His dialectic is motivated by the endless fluctuation (which he called *identity*) between identity and difference. That's why Derrida can say that he was the first thinker of the written word (indefinite opening) and last philosopher of the book (identitary closing).[30] Hegel comes from the future, as long as by future we mean whatever resists the past.

PHILOSOPHY

Philosophy is a continual process of its own redefinition.

MARCUS STEINWEG

CONTEMPORARY ART

Art is contemporary through its futurity rather than through worship of the past or affirmation of a today that is already beginning to be the past of the future. The future is something that rips a hole in the texture of facts. As a tear in the factual fabric, it is present through time. Contemporary art is art that commits itself to this ripping instead of to its universally accepted denial. That is why today's art cannot be called contemporary. All art that opens its present to an indeterminate future—rather than reactively, faintheartedly, opportunistically, and inertly confining it to figures of the present—is contemporary art.

SENSITIVITY

Hypersensitivity differs from sensitivity in that it lacks it. Hypersensitivity is instrumentalized sensitivity, which forfeits its credibility and innocence along with its factuality because of that instrumentalization. What we call regard for the feelings of others is actually their betrayal. We speak of respect, incessantly undermining autonomy with patronizing magnanimity. Protectiveness is violence, even when it's well intended. Hypersensitivity screams for protection because it recognizes its correlate in it. Sensitivity allows for distance from both. Sensitive people reject both of these options: protective hubris as well as the coercive narcissism of sensitized hypersensitivity—what Nietzsche called hyperirritability.[31]

STRENGTH

The critical strength of the work of art lies in the insistence on an *always*. Uncertainty always accompanies our certainties. An element is always inscribed into thinking of the whole that eludes it—one that occupies no position in its totality and remains external to it. The existence of an excessive or transcendent element means that reality isn't everything. It doesn't form a self-contained whole. There are holes of freedom in it, which art cannot afford to resist.

A TEAR IN IMMANENCE

Nietzsche spoke of self-overcoming, while Heidegger chose the formulation "self-overreaching as self-grasping" to designate the transcendental character of the subject or Dasein.[32] In light of these descriptions, the terms human, self-consciousness, ego, and reason lose their substance. They define the subject as a hyperbolic being, an animal gifted with excess. In Heidegger's dispositive, the fact that animals remain caught in their environments, having an environment and surroundings rather than a world, means that they are incapable of excess.[33] Human beings, on the other hand—the *animal rationale* or *zoon logon echon*—are capable of unreason, as long as unreason is understood as the exceeding of reason, tearing of logos, and overextension of economy. That is precisely what makes human beings subjects: the ability to be something other than an object (of

circumstance, time, and culture and language). The subject qua subject is a subject of self-transcendence. It reaches beyond itself. That makes it a feverish vector into the unknown, which inscribes itself in the undefined future as into an incommensurable contingency.[34] It opens itself to its own ontological indeterminacy and restlessness. Should one view this restlessness skeptically (and there are a thousand reasons to do so), or glimpse in it the index of its freedom and opportunity to affirm the self, it seems beyond question that the thing we call the subject is anything but a cogito operating on stable ground. Nancy is right to say that (since René Descartes and Immanuel Kant, along with Nietzsche and Sigmund Freud) we have begun to think "of restlessness in connection to that which is actually 'reason.'"[35] Reason borders on unreason, the subject brushes against its abyss, which neither belongs to the subject nor is external to it. So complex, so contradictory, so unsettling is its situation.

Twentieth-century philosophy began to explore and inspect this abyss. It stands before the double task of limiting rationalist hubris, on the one hand, and resisting the temptation of irrationality, on the other. One can conceive of the abyss as the abyss of freedom, as Schelling, Heidegger, and Sartre did. The experience of freedom becomes the experience of a certain type of horror, the emptiness and desolation in which the subject perceives itself to be situated with the death of God. As *horror vacui*, it is terror at the absence of given meaning. Like Nietzsche's madman in section 125 of *The Gay Science*, the subject experiences

its world unchained from the sun and plunging in all directions:

> What were we doing when we unchained this earth from its sun? Whither is it moving now? Whither are we moving? Away from all suns? Are we not plunging continually? Backward, sideward, forward, in all directions? Is there still any up or down? Are we not straying, as though through an infinite nothing? Do we not feel the breath of empty space? Has it not become colder? Is not night continually closing in on us? ... God is dead. God remains dead. And we have killed him.[36]

With the unchaining of the earth from the sun and the death of God, the subject experiences the instability of reality as the inconsistency of its world. The experience of the abyss becomes the experience of an elementary disorientation and freedom, which implies a certain "suspension of the Ground."[37] It is the experience of ontological incommensurability, which denounces the incommensurability of everything the subject holds as commensurable—all its certainties, values, evidence, and consistencies. In the existential philosophical sense, it is confronted with nothingness, which is another index of its desolation and loneliness.[38] There is no guarantee of sense or meaning or value. There is nothing but a growing wasteland: the indifference of the cosmos toward humanity, which a few practitioners of speculative realism and object-oriented philosophy address today.[39] The cosmos is acosmic. Instead of representing a sensible order, its accelerating expansion burst into

MARCUS STEINWEG

nowhere. It would be rightly termed the *ontological distraction* of the totality of being. Nothing implies that it is subject to the least regularity.[40] Wittgenstein saw the wonder of the world not in how it is but rather in its bare existence— "not *how* the world is, is the mystical, but *that* it is."[41] The "miracle of the existence of the world" indicates its contingency and inexplicableness.[42] Contingency and inexplicableness, however, don't just apply to the how of the world (its immanence) but also its bare fact-that (the transcendence implicit in it).

There is no transcendence if the word refers to another world or a hereafter. But the fantasy of another world cannot be replaced with a fantasy of this one. That is Nietzsche's most basic lesson: that we must think of the infinite under the condition of the finite, freedom under the condition of constraint, and transcendence under the condition of immanence, all without reverting to religiosity. There is, of course, nothing but immanence. Yet it is a *torn immanence*, as Frédéric Neyrat put it in reference to Nancy.[43] The tear in immanence opens immanence within itself. The tear holds it open and prevents it from closing. That doesn't mean that the world of immanence (this world, constituted reality, the divided world, the homogeneous space of facts) opens onto a second world of transcendence (the beyond). This is not the two-world ontotheology of classical metaphysics. Instead of opening into an opening, it opens into closure.

For the world is the gulf that swallows every type of backworld. The world is strangeness itself, absolute

strangeness: the strangeness of the real, the quite tangible reality of this anomaly or of this exception devoid of all attachment.[44]

Access to a second world is precluded by the fact of its nonexistence. If God is dead, then there is no second world. But there is a door. But this door doesn't open to the outside. It opens to the inside. It opens immanence to its implicit transcendence. Not the old metaphysical-theological transcendence, of course; there are no givens and no positive entity whatsoever. This immanent transcendence indicates nothing more than ontological inconsistency and the nonclosure of the fabric of immanence.[45] In a conversation with Daniel Tyradellis, Nancy elaborates:

> When I say immanence, you'll immediately ask if it is the immanence of Deleuze. No, not as Deleuze meant it. To put it another way: This pure being-in-itself and remaining so, the in-itself—of Hegel, if you prefer—this in-itself of Hegel is stiff, mute, and of no use. Something is of use when a self (provided there is such a thing) extends beyond itself, becoming "of and for itself" and so on. But terms like wisdom and knowledge are always taken to mean something like a final state, a (finite?) state, in which one neither needs or wants anything else, and in which one also no longer desires. And Deleuze—who in a similar fashion declares himself to be against the longing for the end of desire—thinks of longing, like wisdom or knowledge, as a state in which

MARCUS STEINWEG

there is nothing more to desire. But what does that mean? Maybe thinking, above all, means desiring. And I would say that to desire means to orient oneself toward something, to allow something to push you into a state of tension.[46]

Desire rearranges thought and fosters its tension. It stretches thought across what I call *transcendence*: the inconsistency of the fabric of *immanence*, *the world*, or *reality*. The fabric of immanence in itself is not a tranquil zone. Its promise of peace reveals an abyss of ceaseless turbulence *ex negativo*. This turbulence does not only affect the subject. It affects the entire world structure, the acosmic cosmos that moves and accelerates into the indeterminate. Now everything comes down to evaluating how a mode of thought can react to this "restlessness of immanence."[47] Certainly not by minimizing, neutralizing, or ignoring it. Rather, by affirming that thinking has been contaminated by it, and constituting itself as thought of unrest in both senses: as restless thinking about unrest, and high-tension contact between the world's inconsistencies. The tears in immanence reveal the constitutive fragility of the texture of reality. Like the subject, it is devoid of all consistency.

HAND

"I really do think with my pen," writes Wittgenstein in a note collected in *Culture and Value*, "because my head often knows nothing about what my hand is writing."[48]

WORLD

This term is a nonconcept. It overshoots the conceptual by overextending the borders of the concept, which no longer evokes anything conceivable, merely the hyperbolic excess of an exploding totality. The world is the entirety that eludes us. The totality of being at the limit of being. Something that reaches out of nothingness, whose manifestations indicate the absence of a closed totality. The world is the index of nothingness, and thus to be in the world is to be poised above nothingness, to give nothingness a face that reveals its nature. The world could be called the dynamic unity of chaos and cosmos, the chaosmotic universe (here you would verge on the thinking of James Joyce, as well as Deleuze and Guattari). One could also say that the world expresses or articulates an intertwining of transcendence and immanence. *World* would be the mainly witnessless, occasionally witnessed, described, and wondered at articulation of indifferent world affairs, the articulation of the totality of being as the unfolding of its fissures and discontinuity. This is why this term refers to the concept's excess, as to that of thought. Thought that is open to the world was first opened by it, not through a gentle, yielding process, but unrelentingly. The world burrowed into our thought long ago. It explodes again and again, ever anew in the subject's heart. It demonstrates its indifference toward the subject, its ontological independence. Thus, it never stops antagonizing the subject, since, after all, to be a subject is to resist the world in the midst of the world.

MARCUS STEINWEG

SELF-OBJECTIFICATION

Anyone who believes that the philosophy of the subject can be replaced with a philosophy of the object has regressed to a pre-Hegelian state.

DRIFT

"There is always a little *gaucherie* in intelligence," writes Roland Barthes in his essay on Cy Twombly.[49] It could also be called the drift of thought. Or the witch's flight, as Deleuze does. He says thought follows a line described by the witch's path. (Barthes, on the other hand, speaks of "the trace of this light swarm of bees" in reference to Twombly's lines).[50] Precisely in this sense, it is not obedient. It breaks with established patterns, venturing the experiment of self-detachment that makes its path indistinguishable from aimless wandering. Gaucherie, drift, swarming, and self-detachment are all part of philosophical as well as artistic thought. In *L'Abécédaire*, under the letter "C comme Culture," Deleuze says that philosophy only remains philosophy by going beyond itself. Leaving itself is constitutive. The excess of philosophy must be an excess within philosophy, the crack or rupture of (or in) immanence. (Philosophical) thought only exists with knowledge of this rupture, which implies the knowledge of a difference that cannot be assimilated. That's why Hegel begins his dialectic with a torn sock: "A torn sock is better than a

mended one ..."[51] Speculative dialectic shouldn't be seen as mending. It appraises the hole in the sock before it sees its task as repairing the sock. A bit of gaucherie in thought also means a little contingency and indeterminacy, a little freedom, a little future, a little scatteredness. Only in drift does thought meet itself. Not in order to speculatively perfect itself, but rather to affirm itself as drift. As a voyage that leads into uncertainty.

DURAS

Marguerite Duras generated her own concept of literature. She called it writing (*écrire*). Writing differs from literature in that instead of presenting a consistent plot with consistent characters, it maintains its connection to the inconsistency of the world and subject. Writing opened itself to Duras through the hole-word (*mot-trou*) and its inner shadow (*ombre interne*). Both words point to the rupture in being or point of inconsistency in reality. Writing encircles an emptiness and absence. Duras speaks of a literature of urgency. The goal is to "catch the words as they come." That only works if you write quickly, rushing past yourself. It demands the willingness to receive what comes and one learns: "Il faut laisser faire quand on écrit, il ne faut pas se contrôler, il faut laisser aller parce qu'on ne sait pas tout de soi. On ne sait pas ce qu'on est capable d'écrire."[52]

MARCUS STEINWEG

EXCESS

The idea that the "being" or "substance" of humans lies in their "ek-sistence," as Heidegger claimed—and he put "being" and "substance" in quotation marks, since these terms belonged to the traditional metaphysics that he was questioning—means that it possesses originary transcendence. But that means that a certain beinglessness characterizes the human being. Heidegger restores the ontology of being by suspending it directly. He sets (human) Dasein free—that is, into the excess of itself. Perhaps things must be taken one step further by conceiving of ek-sistence as inconsistency. The being of the being without being, which Heidegger calls Dasein or the human being, lies in its inconsistency. Ek-sistence would just represent a moment in the comprehensive definition of its ontological character, marked by the word inconsistency. In any case, the term human remains insufficiently conceived as long as it only describes what is conceivable about humans rather than taking into account what is inconceivable about them: their opening to a vagueness that carries thought to the edge of the thinkable. The *subject* describes an emptiness that is the abyss of this vagueness. The "human factor," says Lacan in *The Ethics of Psychoanalysis*, is "that which in the real suffers from the signifier."[53] The human does not merge with the order of the signifier. It resists its own disappearance in the symbolic space. Instead of assimilating with the patterns of fact-oriented humanism, the humanity of humans persists outside the human as social, political, and cultural

figures. Fact-oriented humanism is my word for all anthropo-ontologies that define the concept of the human by excluding the dimension of the "nonhuman" and "inhuman." This dimension delineates the borders of the space of facts, along with its defining practice of reducing the human to "the self" (its "humanity," its "form")—an attempt to force the human smoothly into this space. The human becomes another fact in the world of facts rather than marking its limit and porousness. By conceiving of the unconscious as the exterior of the subject, Lacan conceives of it as an implicit exterior or immanent transcendence.[54] But this isn't a vertical (religious or theological) transcendence. The unconscious marks the hole in the subject—an emptiness or wasteland. It holds the subject open to its exterior, which rather than being exterior to it, takes the place of its (deficient) being, as subject of the unconscious or exterior, and therefore of a wasteland. I call this a subject without subjectivity. It identifies itself with an elementary deficiency. But this deficiency doesn't indicate defectiveness. It marks what Sartre calls the hole of freedom. In Lacan, who follows Sartre in many things, freedom becomes complex. Freedom now means I am the excess of myself.

ELEMENT

What is the location of thought, its environment, situation, reality, and element? The answer to these questions would point to their inadequacy, narrow-mindedness, and reactionary character. What's more, questioning the element of

thought seems prefigured by this element, which turns the activity called *thought* into a mode of self-articulation. Self-articulation of the element is self-explication of the substance. That's precisely what Benedict de Spinoza says. That's why Hegel, Nietzsche, and Deleuze recognized him as a predecessor, brother, and prince.

FLOATING ARCHITECTURE

Thought on the subject of irreducible difference (whether it concerns *writing* in the Derridean sense—that is, that which poses an integral resistance to phonocentrism, or thought on the *fathomless foundation* or *foundational abyss* in the Heideggerian sense)—belongs to the tradition of metaphysical thought insofar as "the term metaphysics indicates the tradition of thought," as Agamben writes, "that conceives of the self-grounding of being as a negative foundation."[55] Metaphysics is the opening of the thinking subject to the unthinkable whose dynamic is the founding of the self, with the recognition that the self is a floating architecture.[56] The subject mediates itself with itself by entrusting itself to the limits of the self. Trust must be an anti-illusory practice; it must replace the illusion of pure self-foundation with itself. Rather than indulging in the naïveté of ultimate self-control, metaphysics is the knowledge that cannot stop knowing that knowledge isn't everything. Without straying into religiosity, it is the thinking of the unthinkable beyond religious self-effacement, thought that pushes its concepts to their limits and hones its vocabulary on the impossible.

This thought attempts to use the concept to get beyond the concept, as Adorno put it. It is an effort that inscribes difference into the concept instead of locating it beyond its identifying violence. To think in concepts is to reach for the extraconceptual. The concept borders on the region of the nonconceptual. It exists only in the form of this border contact, as exceeding or excess—that is, as ecstasy of a form that is no longer closed to the formlessness of preconceptual entities.

WANDERING WITH FOUCAULT

Thought entails wandering as well as straying into madness. If you don't risk going astray, wandering about, even to the point of madness—insanity, as people put it, without ever knowing what that means—you only think you're thinking, while actually you're stuck in the conventional without risking any sort of experience. In a conversation with Claude Bonnefoy, Foucault—for whom the concept of experience is central—links the experiment of (philosophical) writing with insanity. "I couldn't tell you why writing and madness communicated with one another for me. Most likely, what brought them together is their nonexistence, their nonbeing, the fact that they are sham activities, lacking consistency or foundation, like clouds that have no reality."[57] Writing and madness share the experience of clouds of inconsistency. This has nothing to do with romance. The romantic dispositive—which expresses an unreflected narcissism—entails the longing that stabilizes the subject,

barring it to any experience of destabilization. Everything has been decided in advance. The outcome of the story is a foregone conclusion. It ends tragically because it must end tragically. Only in tragedy and unfulfillment does the narcissistic-romantic self come into its own. Thus it successfully prevents itself from being a subject. Romance successfully objectifies itself. The romantic self constitutes itself as the "victim" of its "feelings" and "longings." At the same time, it is completely determined by the history of the genre of *romance*. It propels itself down a track that leads it toward unhappiness. What Foucault calls *writing* demands the willingness to break out of the narcissistic-romantic dispositive. Writing lets the subject jump the tracks of teleology. It distances itself from itself in order to approach itself. It goes places other than where it has been or should reach. Only elsewhere does it meet itself. As Foucault puts it, "After all, what would be the value of the passion for knowledge if it resulted only in a certain amount of knowledgeableness and not, in one way or another in the knower's straying afield of himself? There are times in life when the question of knowing if one can think differently than one thinks, and perceive differently than one sees, is absolutely necessary if one is to go on looking and reflecting at all."[58]

TOXIC CONCEPTS

As hyperbolic, empty, toxic categories, truth, reality, freedom, justice, the subject, and so on, point to the holes in the fabric of fact by indicating its fragmentary nature. Our

world—what we refer to as our world—is a porous web of facts. It lacks all consistency and conclusiveness. It contains grounds but has no one ground. It is architecture suspended over the abyss of its contingency. Philosophical concepts point to this abyss. They attest to the unattestable. That makes them just as fathomless as they are contagious. They are concepts that carry the germ of destruction within themselves. They transport their death and impossibility. They carry within themselves the ability to liquidate all realities. They're destructive concepts insofar as they undermine all political, social, cultural, and economic constructions. They have the power to destroy through unreality.

CRAZY?

Who is crazy enough to think that the entities known on the stage of the occidental theater of reason as *logos*, *ratio*, *cogito*, *raison*, and so forth, are not insane? What would thinking look like if it were ignorant of its own madness? What would be the subject of this ignorance? And would it still be a subject, an authority that legitimates itself before itself? Hardly. The madness of reason always lies in the contestation of its madness. When madness believes it can free itself from madness by invoking reason, thought is insane. But that's what's known as a *subject*, says active nonthought. No, it is the lack of thought in the midst of reason.

MARCUS STEINWEG

LEAP

Nancy once said, "In the method of thought, in thought as method, there is nothing more important than the leap." The leap is "the connection to the incommensurable. One leaps when there is no common measure. One leaps because one is in connection with that to which there is no connection."[59] Leaping thought survives in the tension of this connection to the unconnected. Leaping, it experiences itself as necessity and aporia. As it leaps, the subject leaves itself and the ground beneath it. It leaps away from and out of itself. Un-self-assuredness is part of leaping. The subject separates from itself in order to encounter something foreign. The leap interrupts the dialectical circle. The return to itself becomes a meeting with a self that doesn't exist as such. Leaping affirms the inconsistency of the leaping subject. It leaps through itself as through a hole, without knowing where it is going. That differentiates the leap from the step. Thought that moves in steps, without leaping, is called argumentation. Above all, it is an illusion. It only imagines that it articulates itself via a secure sequence of steps, which exempts it from leaping. But it too is leaping, even if unwillingly and unknowingly. Leaping thought, on the other hand, is aware of the holes in the ground it treads. Instead of taking one step after another, it leaps from plateau to plateau, like a character in an early computer game. It leaps up and down, left and right. As long as it keeps leaping, it will not be doomed to its identity (or whatever it considers to be its identity). The leap prevents it from entrapping itself in a self

and origin. Instead of jumping back behind some origin, as Heidegger's thought demands of itself, it leaps past any fantasy of origin. A leap only exists as a leap into uncertainty. It shouldn't be confused with Søren Kierkegaard's leap of faith. It is a leap away from any certainty of faith.

CRITICAL?

One considers oneself critical, when in fact one is opportunistic, self-righteous, and stupid. One defines oneself as political, but has long been depoliticized by appealing to what is right. One associates the affirmation of the established narrative with the stereotype of the critical ("critical questioning" or "inquiry"), without noticing that one robs oneself of the possibility of critical thought (that is, of thought tout court) by failing to consider a criticism of criticism (which would imply self-criticism). Rather than analyzing the limits of criticism, one repeats the usual pattern in order to position oneself most advantageously in the panorama of established values, opinions, and evidence. The focus lies on favorable self-positioning as opposed to criticizing the conditions that the critical subject must include in the critical dialectic, instead of conveniently excluding them. Pseudocritical opportunism long ago took the place of thought (which never emerges or survives without its aporia, and entails foundering). One thinks one is practicing something like "radical critique," says Nancy in *La pensée dérobée*, by accusing the "world" of being a "shop window": "But then one would also have to add that what one sees

MARCUS STEINWEG

there is precisely the world (*le monde*) and nothing else—dirty (*immonde*) and cosmological at once—and that it has no recourse to the reality of an 'earth' and/or a 'heaven,' which one could contrast with 'phenomena' or 'simulacra.'"[60] The society of the spectacle performs and reflects the image of an actually existing world or reality. But that means that critique—critical thought and critical cluelessness regarding the limits of this thought, or what we provisionally call thought—begins with the questioning of the logic of opposition, of binary formalization and simplification (which is the minimal requirement of Derridean deconstruction). Critique is critique of simplification by means of affirming the latter's critical indispensability. No critique is exhausted in the commensurable. True critique means going beyond that model. It risks losing itself in the process of exceeding its criteriology in order to experience measurelessness and heterogeneity, which belong to experience qua experience. The value of an experience becomes apparent in the urgency of the suspension of the "critical" experiencelessness that it catalyzes. Those who are critical critique the criteria that order their world (or their shopwindow) in a way that subverts their critical faculty.

DERRIDA WITH DEBORD

In 1967, Guy Debord recognized and predicted that the society of spectacle—modern-day capitalism—"eliminates geographical distance." He was referring to the way global market activity had become simultaneous, as digital finance

metaphysics demonstrate today.[61] In the same year, Derrida published *La voix et le phénomène*, *De la grammatologie*, and *L'écriture et la différence*. In their most essential form, these texts concern the autoaffection-related suppression of spatial and temporal distance (which is the dynamic and praxis of metaphysics characterized by logocentrism). What Derrida calls *différance* and associates with the concept of *espacement* implies an economically critical impulse. Thought (emancipation, politics) entails making time for time, accepting that there is space between here and there— that is, difference. *Différance* marks resistance immanent in the system, resistance to the market's homogenizing tendency. It is irreducible heterogeneity and nonsimultaneity. Derrida shares with Debord the knowledge of the limits of a world committed to the fantasy of the limitless.

STUPIDITY

The stupid deny their stupidity.

SELF-IMPLICATION

Whatever the thinking subject thinks always applies to itself. Thought cannot spare itself this self-implication. The subject's disinterest in its judgments, disavowals, wishes, and hopes can be identified as nonthought. Not thinking is denying implication. Nonthought preserves a sort of safety margin around itself, making it a narcissistic practice. For

MARCUS STEINWEG

what is narcissism if not protectionism applied to the self? The subject believes it can protect itself from itself by claiming disinterest in the incommensurable, inconsistent, and uncontrollable parts of itself, all the while clinging to delusions that suggest a misleading consistency. As everyone knows, this calculation doesn't work out. Narcissism is a form of self-assertion based on self-denial. Self-implication implies breaking with narcissistic protection.

FRAGMENTARY

Philosophy only exists as the experience of the fragmentary nature of established "truths" and loosening of the thinking subject's bond to reality. Not to indulge in flights of fancy, or to flee from the facts in the "heaven of abstraction," as Louis Althusser calls it, but rather to demonstrate the inconsistency of facts by opening to consistent dreams—dreams are not flights of fancy.[62] "Experience can only make you blind," says Heiner Müller, which means that every experience worthy of the name entails the nullification of certainties.[63] The subject experiences the fragmentary nature of its world. Its evidence eclipses itself. The most lucid experience of this eclipse is the elementary experience of philosophy.

PARROT

Living with a phantom isn't as harmonious as with a parrot that you've taught your own language.

FANTASY OF CONSISTENCY

Art and philosophy share a resistance to the religion of facts. Authors like Nietzsche, Adorno, Lacan, Duras, and Müller share a consciousness of the inconsistency of the fantasy of consistency known as *reality*. Neither idealism nor realism is acceptable because realism itself already represents a sort of fact idealism. A large portion of contemporary art is based on this obscurantism of facts. One considers oneself critical, all the while clinging to facts whose arbitrariness remains unexamined.

SUBJECT

How much of the subject survived its death? This is the central question of contemporary philosophy. Is there a subject after the subject—after the analytic invalidation, deconstruction, and questioning of the category of the subject by Nietzsche, Freud, and Heidegger, for example, as well as the movements known as structuralism (Althusser, Lacan, Foucault, Barthes, and Claude Lévi-Strauss) and poststructuralism (Deleuze, Derrida, and Nancy), and twentieth-century philosophy (including critical theory and media theory) as a whole? Can one do away with this category? Has it already been done away with? What would thinking look like if it weren't the thinking of a subject (*genitivus subjectivus*) anymore—that is, a minimally self-transparent consciousness or ego, an infinitesimally consistent agent and cogito of this headless practice known as thinking? The subject was

MARCUS STEINWEG

possibly never anything more than the theater of agonizing self-deconstruction, which is why Derrida could say that from the beginning, the point of deconstructive practice was "to reinscribe the unction said to be that of the subject, or, if you prefer, to re-elaborate a thinking of the subject which was neither dogmatic or empiricist, nor critical (in the Kantian sense) or phenomenological (Cartesian-Husserlian)."[64] Perhaps there has never been a subject that wasn't the result of self-mediation, with all its impossibility and inconsistency. Perhaps the subject was always beyond the subject, beyond itself as it is beyond any coupling to itself. One can call this self-mediation, with its excessive aspects, *dialectic*. It is in no sense a happiness-in-unhappiness dialectic corresponding to a known Hegelian orthodoxy according to which, as Heidegger once said, the Hegelian spirit (or subject) is set on rails and a true derailment remains impossible.[65] It is a dialectic with an open ending, a process of contentious self-mediation that never comes to an end. It is related to Adorno's negative dialectic in that it fuses affirmative moments with critical ones. In it, the subject neither comes to accords with itself nor attains peace. In the process of its dialectical mediation, it experiences itself as the subject without a self. It is a subject without subjectivity.

BODY INTELLIGENCE

The body has a memory and possesses an intelligence that directly repudiates the impressions made of it. You could

say that it denies its intelligence. But precisely *that* is its intelligence!

FOR INSTEAD OF AGAINST

Just as philosophy is not philosophy *about*, nor is it philosophy *against*. Philosophy always goes beyond *about* and *against*, and toward a *for*: thinking *for* the indeterminacy of that which doesn't (yet) exist. "No book *against* anything ever has any importance; all that counts are books *for* something, and that know how to produce it."[66]

VISION

How to conceive of reason (or the soul) when, by identifying itself as a prisoner of the body, it actually imprisons the latter? To think of Plato with Foucault, and Foucault with Plato, could be the imperative of thought that resists the esotericism of the body along with faith in reason. If the body empowers the soul (logos, speech, and reason), while the soul blathers on unchecked, you have what you could call chatty sexuality. It maintains an intimate relationship with words, confession, and prayer. Its corresponding "logic of sex" delegates sex to the "desire for analysis," to a confession culture, an erotics of whispering, interpreting, and evaluating, to a truth that is believed to reveal the deepest layers of the subject, its libidinal foundations. Foundation or abyss, grounded or fathomless—undoubtedly this

discourse, which associates the truth with sex and sex with the truth, revives a metaphysics of interiority that proves to be the thinking of the subject's identity and its sensual sub-jugation to the logic of confession, since enjoyment gives "phantasmic support" to "discourse[s] of power," as Slavoj Žižek writes, and there is no enjoyment that is not the enjoy-ment of power.[67] Accordingly, this chattering eroticism is anything but innocent. It maintains contact with the concept of guilt by associating it with the category of the truth. It remains marked by the possibility of enjoyment that brings the subject into contact with its desires, only to delegate them to its conscience and the punitive gaze.

LOVE

"*L'amour c'est offrir à quelqu'un qui n'en veut pas quelque chose que l 'on a pas.*" / "*Love is giving something you don't have to someone who doesn't want it.*" Thus Lacan's famous formulation, in which one detects a trace of the tragic para-digm. And what if love manifested itself in an act in which *someone refused to give something they had to someone who wanted it*? Would this refusal describe the "love" of the analyst for the analysand? It would be unreceptive and cold, but also less unreceptive and cold than romantic love, which takes the failure of love as its condition—from the very outset!

EXTREME

Without risk neither thought nor art is possible. Doesn't this sort of heroism not only prove untimely but also often lead to embarrassing posturing? The first reaction of aesthetic doxa exhausts itself turning its nose up at the anachronistic affectation of the daredevil, which is associated with the romantic-genius aesthetic and masculine self-assertion. Is that wrong? No, but it isn't right either. Yet—like every reaction—it speaks in the name of what is right. A timely, untimely conception of risk would imply the courage to affirm artistic and philosophical thought as figures of resistance to the imperative of what is right. In the context of this thinking, art and philosophy are the self-extension of the subject toward its exterior, allowing it to reach an extreme and pinnacle. It would be in contact with its own impotence. Only in opening to its powerlessness can the subject arrive at formulations of itself and its world that amount to more than expressive gesticulation or documentation. "The work of art," writes Maurice Blanchot in *The Space of Literature* in reference to a letter from Rainer Maria Rilke to Clara Rilke, "is linked to a risk; it is the affirmation of an extreme experience."[68] As such, it is the affirmation of experience itself, as long as by experience, we mean the subject's self-destabilization in the real in the Lacanian sense, or nothingness in Sartre's sense. An experience is by definition the experience of an extreme. It destabilizes the subject and tears it out of its realities. Only experience can create a subject whose truth lies not in its evidence but rather in its

MARCUS STEINWEG

inconsistencies, the truth of being a torn entity stretching to the abyss of its contingency.

INCOMMENSURABILITY

Like love, the experience of the beautiful remains open to the incommensurable, which eludes direct experience. The beautiful is the portion of it that manages to communicate itself anyway. Beauty reflects the world's inconsistencies.

ASSERTION

Philosophy isn't about proof. It's about unprovable assertions struggling for evidence.

HARMLESSNESS

It is the dictate of the era. It correlates to the opportunism of assimilation. To be politically—or artistically or philosophically—inoffensive today means to neutralize oneself politically or depoliticize oneself through overpoliticization—that is, moralization—which comes down to the same thing. Harmlessness is the extremism of the cowardly, who get a clear conscience in exchange for maintaining a safety margin that they call being *critical*. Nothing is less critical than the *criticality* of subjects who believe themselves untouched by realities that they construe as reactionary, all the while considering themselves

to be active, engaged, and left leaning. The harmless preach their assimilation as realism.

THE TEXTURE OF FACTS

The texture of facts is what I call the universe of manifest knowledge, whether it is scientific, cultural, religious, economic, political, or technical in nature. The subject emerges at the edges of the fact world, where it is suppressed and omitted. It marks the border of the factual present. A subject is that which is more than an object. Irreducible to its status as object, which defines its reality in the space of facts, the fact-subject nevertheless remains the object of factual codification. It is the subject of objective lack of freedom in the midst of the sociopolitical texture. There is a subject if there is something that cannot be assimilated into this texture, as long as the porousness of the fabric of facts is apparent. At the moment in which the ontological fragility of the fact world flares up, the presence of a subject is certain. That's why it can be said that it is a figure of resistance. It resists the roll call of facts, which catalyzes its disappearance from the objective texture.

CULTURE

"Culture is an observance. Or at least it presupposes an observance," wrote Wittgenstein in 1949, in *Culture and Value*, a collection published posthumously in 1977.[69] Which means that it corresponds to a *language game* or *form of life*

MARCUS STEINWEG

in the Wittgensteinian sense. It is not a value-neutral or, as Deleuze and Guattari would put it, smooth space (*espace lisse*). It is itself a system of references, while also corresponding to a system of references. Can art and philosophy be defined as culture in this sense? Isn't it true of both that they formulate an objection to their element without corresponding to an observance, system of references, language game, or form of life?

CAT

Why should a cat be more mysterious than a dog?

BEAUTY

"*Beauté est vérité*," writes Yves Bonnefoy in *Le Lieu d'herbes*, associating beauty with a certain restlessness (*inquiétude*) and a sort of fever (*fièvre*).[70] Does that mean that the truth of this sentence lies in its reversal? *Truth is beauty* could be the truth of the sentence *beauty is truth*, if truth is understood here as the most extreme degree of fever and elementary restlessness. Beauty is truth because truth is beauty insofar as the term freedom marks the ultimate invalidation of all validity. That's why Wittgenstein could note in *Culture and Value* that "what is pretty cannot be beautiful."[71] The pretty is without truth. Unlike beauty—and still more, unlike the sublime—it arises when the abyss of ontological inconsistency is hidden. The term *truth* identifies this abyss.

CLICHÉ

We often say, "That's a cliché," feeding the cliché of the cliché.

FINANCE ROMANTICISM

Perhaps the task of art and thought today lies in wearing away at the borders of the economy, which a hyperbolic romanticism of finance makes it easy for us to forget. Everyone knows that at certain moments, the Christian god was replaced by the romantic, avant-garde, and modern artist-subject. Today this subject has been declared dead. But as with God, its death is accompanied by endless agonies. The portion of it that can't be killed survives in the creative sector of a finance metaphysics that purchases its realities with credits, or credos as it were.

DREAM

"You were only dreaming," the parents comfort the child. "It was just a dream!" Just a dream? At this point the child begins to suspect who the real dreamers are. Because the dream conceals a truth? Because the idea of a dreamless reality reveals the realism of adults as dreamlike.

A VIEW FROM SPACE

"Things look totally different from Mars," notes Müller on our realities.

EVIDENCE

"What is evident is violent," says Barthes, and he's right, by dint of having written such a forceful sentence.[72] That's how overwhelming its evidence is.

TUMBLING

There is an acrobatics of thought, through which thought affirms its incompetence and trusts in the experience of failure. In failure, the subject comes into contact with itself. Not every encounter with the self remains illusory. The subject could also be called that which grazes against itself in the mode of transgression. Its experience of itself is the experience of the alien. Only in transcending itself does it come into contact with itself. This self-contact is not narcissism. While the narcissist aims for self-affirmation, the subject without subjectivity loses itself in the desert of this lack. It transcends itself to another world beyond itself rather than clinging to an ideal as the narcissistic subject does. There is no self-affirmation in excess. All contact with the self implies falling short of the self. "Man begins again and again to surpass man (this is what has always been meant by 'the death of god,' with all of its possible meanings."[73] Which is to say, humanity entails the loss of itself. That is a feverish fate. It does not arrive at itself and it does not come to rest in itself. It is not transparent to itself. It never was. As Badiou writes, "God is dead means that He is no longer the living being who can be encountered when existence breaks the

ice of its own transparency."[74] You don't encounter God by encountering yourself; you don't even encounter yourself. That is why the fever known as excess can also be described as touching the untouchable: *"L'excès est un accès—à l'inaccessible."* / "Excess is access—to the inaccessible."[75] Like Blanchot's *pas au-delà*, the (non)step into the (non)beyond is a step into this world.[76] It is not an absolute other world, which is why it is touchable while remaining untouchable. It is the name of this logical contradiction. In it, presence and absence, consistency and inconsistency, being and nothingness, corporeality and incorporeality, merge.

MEANING

Instead of inquiring into the meaning of concepts, philosophy pursues the meaning of the use of concepts in the context of their meaning.

TRUTH

My definition of the truth differs from at least two conceptions of the truth: the Thomistic and Heideggerian concepts. The Thomistic formula, which can be traced back to Aristotle, is well known: *"Veritas est adaequatio intellectus et rei."* / "A judgment is said to be true when it conforms to the external reality." According to this view, the location of the truth is the expression of judgment. A confirmation of the truth occurs in the expression. In *Being and Time* (especially section 44), Heidegger transferred the location of

the truth in relation to the expression by questioning the primacy of the logic of the expression to philosophy. For Heidegger, the expression is not the location of the truth. The expression itself belongs to a space of truth that he calls "disclosure" (*Erschlossenheit*). There must already be a "relationship of Being" (*Seinsverhältnis*) between the subject of the expression and its objects, an "understanding of Being on the part of human existence" (*Seinsverständnis von Seiten menschlichen Daseins*) before we can speak of this knowledge relation and its expression. In Heidegger, the traditional metaphysics of knowledge are displaced onto the opening of the relationship of knowledge to this ontological priorness of a relation of being that is previous to it. Its objective is to wrest philosophy from the primacy of epistemology. Existential ontology resists the neo-Kantian reduction of philosophy to epistemology and the declawing of philosophy that it entails. The tradition of German idealism is one in which the relationship between epistemology and general ontology is exemplified. It would be an error to simply attribute it to the philosophy of knowledge. The question of the limits of the human subject's knowledge is already itself a question of its being as consciousness of knowledge and the self. It is a question that opens onto the subject's ontological fragmentation, just as the first sentence of the first edition of the *Critique of Pure Reason* does. Heidegger's contribution was refusing to accept the reduction of philosophy to epistemology, dislocating epistemology itself into that which he called truth or disclosure or *aletheia* as the space of unhiddenness, in which the relationship of being

between human Dasein and that which is, the essent (*das Seiende*), is already established. Apparently, what is at stake is this notion of a sort of a priori, a certain priorness, which precedes the relation of knowledge as its transcendental condition. As is clear, the term *transcendental* amounts to *enabling*. When Kant speaks of the transcendental subject, of being as transcendental subjectivity, he means that structures collect in the subject's subjectivity that allow for a relation to the self and world. That is the sense of the word transcendental in Kantian terminology.

In contrast to the Thomistic conception of truth, which reduces truth to the logic of expression, and in contrast to Heidegger's conception of truth, which identifies human Dasein as being in the world with an understanding of being, I would like to propose a third conception of the truth. Descartes took a dualistic conception as his starting point, by strictly and nearly platonically separating the subject's corporeality from its status as ego cogito. Heidegger answered the Cartesian dilemma—How can the cogito get out into the world?—thus: I don't need to get it out, since it has long been outside. The cogito is the original ecstasy, originary transcendedness in the dimension of the world, as well as the disclosure of being. The problematic thing about the identification of humanity's being as being-in-the-world is that it permanently cements the human subject with its world. As the original being-in-the-world, Dasein is at home in its world, though Heidegger also speaks of the uncanny, literally the "not-at-home" and "un-homelike" (*Un-zuhause* and *Un-heimlichkeit*), although he understands being-at-home

as a derivative of not-at-home.[77] Ultimately his analysis of Dasein privileges the familiar character of the world in contrast to its uncanny mode, since the world is supposed to be Dasein's sphere of disclosure, where it moves in its element. Even if as unhiddenness (*aletheia*), the truth withdraws into hiddenness and being is understood as withdrawal, Heidegger insists on a vocabulary of *belonging* and *authenticity*, which promises Dasein an ontological home. In contrast to this ontology of the home, I would like to define truth as the border of the universe of fact, the border of this explicative context in which Dasein experientially articulates its relationship to its world and itself. I call the truth that which has no capacity for positivization in the space of constituted reality. The truth is what doesn't exist.

VIRGINITY FANTASY

The fantasy of virginity is the idealistic paradigm par excellence. All idealism refers back to it. It corresponds to the wish that something could happen without happening. Even more than erasing it, the goal is to deny the traces of an act; to free an *event* from its history.[78] One thinks of a child without parents, without sex. As long as causality exists, the idealist will feel threatened. Causality is impure, which is why every kind of idealism—to follow on Adorno—takes the form of the worship of *false immediacy*. Philosophy can be defined as the break with this immediacy. Which is precisely what Derrida does. Deconstruction is the deconstruction of the fantasy of immediacy or virginity. Thus,

it is the deconstruction of the subject in both senses: the subject as object and as subject. The subject makes itself the object of deconstruction. The subject is its problematic theater. Derrida repeated incessantly that deconstruction is self-deconstruction. In it, the subject is in contact with its impurity. The subject exists only in impure, contaminated, toxic form.

BREAK

Adorno, Blanchot, Badiou, and many others agree that philosophy breaks with conventions and dominant ideologies. Mustn't we conclude, then, that the break with ideology and convention is the convention of philosophy and its dominant ideology? Mustn't we break with the break in order to free ourselves from the ideology of the break? Where does the break with the break lead? Does it lead back to continuity with convention and tradition? Does it correspond to the Hegelian sublation of sublation? At least one thing is clear: a break that doesn't break with itself is no break at all. But breaking with itself doesn't mean restoring the fantasy of seamless continuity. Breaking with the break means breaking *differently*. The interruption of ideology *takes the form of* ideology. Breaking differently means knowing that no territory is ideology free. Yet it is possible to evade an ideology with this knowledge. No subject is beyond interests and stereotypes. As long as it keeps that in mind, it is thinking, since thinking means questioning all realities in order to charge their authority with contingency. Thinking means

stepping outside the fiction called *reality*. Does it mean flee-ing into illusion? It means breaking with authority that relies on realities whose inconsistency remains unquestioned.

CONTINGENCY

With the death of God, the subject lost orientation and gained room in which to play. It conceives of itself as the playing subject, whose future becomes more indeterminate as it increases in contingency. It taps into its realities as the product of universal indeterminacy. What is indeterminate is not limited, without being eternal in the theological sense of the word. It is infinity within the horizon of finite subjectiv-ity: nothingness seems to be absolutely predetermined. It could not be otherwise.

FACT ESOTERICISM

Philosophy is a purposefully antiobscurantist practice, which is opposed to all forms of fact esotericism.

BEGINNING

Where to begin and how? You could say you have to start somewhere. But this "somewhere" doesn't exist. There is no innocence of beginnings. At best, one can act as if it were so, which is anything but innocent. One fools oneself and others by trusting in the nothingness of a pure beginning, acting with the nonchalance of a creator-authority who raises

being from nothingness: *creatio ex nihilo*. In the beginning, there was nothing—at least that's what an old myth says. According to it, being and everything in existence is a betrayal of nothing and its purity. The dialectic of being and nothingness never comes to rest. It has troubled philosophy from Parmenides up to us. There is no philosophy that is not ontology, dialectics of the unrest between being and nothingness, presence and absence, consistency and inconsistency, immanence and transcendence. All thought stretches into a void, which at best it approaches as its insufficient substitute. It floats over a void that it cannot subsume. This is why we speak of its violence, of the tyranny of the concept and impertinence of artistic creation. Art and thought cannot rid themselves of officiousness and hubris. Art and philosophy are by definition hyperbolic, unnecessary, and uncivil.

POLITICS

Let us call the sphere of intersubjective relations—be they personal, private, public, local, national, or global—"politics." Let us call the system and function of all possible signs that guide these relations "semiology." This system is undoubtedly already an open system because it is subject to historical transformations and encoding. It does not exist singularly. It lacks any stability or necessity. It is complex. To put it in Kantian terminology, it is an aggregate rather than a system. An aggregate differs from a system in that it represents an incomplete—that is, empirically generated,

MARCUS STEINWEG

synthetic a posteriori—assemblage or structure as opposed to a coherent whole.[79] Political semiology isn't just the study of systems of political signs; it's also politicized symbol theory *in actu*: all domains of intersubjective relations that take place across political encodings, constructing themselves using signals and signs. That is why the act of naming is a receptive act of adopting, extending, altering, and relocating established systems of signs. Every system of signs is a system of orientation. That is its function: to generate orientation through communication. It is always a question of orientation in disorientation; philosophy isn't any different. In reference to the system or empire of signs known as *Japan*, Barthes said "that the exchange of signs remains of a fascinating richness, mobility, and subtlety, despite the opacity of the language."[80] Every system of signs operates on the film of elementary intransparency. The economy of the circulation of signs—the exchange of signs—indicates the opaque ground of every semiological system. Just as for Wittgenstein a language game cannot be grounded in itself, since it itself provides the groundless, abyssal grounds for language use, every system of signs is floating architecture over the abyss of its contingency.[81] It could be called its own mythology. The ancient Greek word *mythos* means speech, history, and story. Mythology is the system of stories told. A system of signs can be defined as a system of commonly used signs that refer to a system of stories told. Political semiology investigates the practice and limits of the circulation of signs in the sphere of intersubjective relations in order to determine the possibility of inventing new

semiological myths. They could be myths of everyday life, as Barthes describes them.[82] They could be incredible myths, unexpected semiological adventures in which new myths collide with old. The point at which new and old mythologies collide is the place where something like the future happens.

The future is what contradicts the past. No future is reducible to the past. Whatever seems reducible to the past already belongs to the past and in this sense is not new. That is why the concept of the future has been associated with the category of the event for so many—Derrida and Badiou, for example, as different as their positions may be. An event is what tears the horizon of expectation. It is the unexpectable. As the unexpected, it is strictly necessary, but its necessity does not follow any (historical) causality. It has the necessity of contingency.[83] The experience of contingency is equivalent to the experience of interruption in the historico-political texture of facts. It is the experience of the cut (*decisio*). The tableau of constituted realities reorganizes itself in the wake of such an experience. It is also the moment of certain inventions: the invention of new lexica and languages for the naming of the unnameable rather than cataloging the known. Political semiology is the semiology of contingency. Instead of enclosing itself within what has passed and what is present, it opens to the inconsistency of established semiotic dispositives, revealing their ontological fragility.

Fragility is an ontological attribute of reality. Reality is always generated over the abyss of its own fragility. It

MARCUS STEINWEG

indicates the instability of all facts, along with the arbitrariness of all semiological mythologies. It's sometimes said that logos is that which distances itself from myth. On closer inspection, it's clear that any logos architecture (together with its associated semiology) produces its own mythology. Logos and myth are problematic siblings. They stumble hand in hand. Which doesn't make them indistinguishable. Logos implicitly promises consistency, first cashing in on a myth, but in an unsatisfying way. The myth is a story that we can only believe (or not).[84] Logos interrupts this story by making us believe that—from now on—we will exist without belief. Politics resides between logos and myth. That also means that it can't make itself choose between two ideological dispositives. It oscillates between two registers, which destabilize each other reciprocally. That isn't a drama; it's political reality. Logos promises to be nonmythical in that it presents itself as an alternative to myth. Myth seduces with its (supposedly) transhistorical (archaic and archetypal) truths, which are supposed to reach deeper than any logos and all knowledge. Only a dialectic of myth and logos makes their compossibility thinkable, which dominates every political semiology. Translated into the Lacanian model, this means that logos (reality or the symbolic order) lies like a diaphanous veil over its mythical core (the real, the truth, which opposes its translation into knowledge dispositives), simultaneously obscuring and revealing it. Once again, we are dealing with the dialectic of the incommunicable. I think that every political sign implies such a dialectic.

Political semiology investigates political signals and signs (and activates them as politically motivated analysis) as the point of contact between the signifier and signified. "The signified and the signifier, in Saussurean terminology, are the components of the *sign*."[85] Perhaps it can be said that the political sign marks a resistance to the doxological components of the signified as well as signifier. It does not allow itself to be pacified by any doxa. It is a restless sign, oriented toward a still-indeterminate future. A sign of the future, here and now.

The function of doxa, established opinion, lies in its promise of peace, in its insistence that everything is already decided.[86] Nothing else contradicts contingency. Politics exists only with contingency. Politics implies that there is actually a chance that the current texture of facts can be changed. Politics that exceed the management of the political status quo cut into the fabric of facts. They tear the fabric. They do it using resistance and affirmation. They resist what is given—the "power of the existing," as Adorno and Max Horkheimer put it. Their affirmations do not affirm what is. They affirm what isn't or what could be, while the authority of fact claims that it's impossible. Political affirmation of the impossible affirms the suppressed and invisible parts of established reality. It opposes the sense of possibility that is compatible with the promise of peace or order. Political opposition resists the possible by affirming the possibility of the impossible. The dialectic of possibility and impossibility is essential to it. Thus it establishes the difference between choice and decision. Choice differs from

MARCUS STEINWEG

decision in that it opts for the possible. One who chooses selects among available possibilities. One who chooses selects the established power. To choose means to choose among given options. A decision opposes the texture of options that is our reality. That is the meaning of *decisio*: to carry out this cut in the fabric of reality. To decide is to opt for an option that hasn't been given. One who decides "chooses" the impossible—that is, that which cannot be chosen. Every decision implies a complete reconfiguration of the political field (including the political semiologies that control it).

The decision poses a new reality. It redefines the world. That's why it can be called ontological. Rather than effecting administrative self-depoliticization, it suspends the political decision-making of the established political model. Herein lies its moment of resistance and anarchistic quality: in the refusal to leave the world in its present state. Let's call it a politics of contingency. It insists on the possibility of the impossible, which manifests itself in an image of a "radically different" future.[87] Derrida associated such an image with "a 'yes' to the other."[88] A yes to the other is a yes to contingency. It reflects Nietzsche's *amor fati*, affirming the contingent character of the world.[89]

The contingent is what could be other than what it is. The contingent jabs a hole in being.[90] The hole of contingency marks its abyss. This is the abyss of the real—that is, the abyss of nothingness. All thought that frees itself from the illusion of metaphysical self-justification and ultimate justification orients itself toward this abyss (though its

freedom is a task that cannot be completed rather than an established fact). The ground of all thought is fleeting. The thinking subject thinks on a fragile terrain. It circles a void that extends beyond it. It orbits the abyss of reality. It is circling thought insofar as it maintains contact to the impossibility of thought.

Thought is the thought of the impossibility of thought. In thinking, thought refers to its own inconsistency. The inconsistency of being is the inconsistency of thought. Thought that thinks itself does not access itself as *fundamentum inconcussum*. It recognizes itself as essentially ungrounded. Its grounds—the terrain on which it moves—are diverse and contingent. When the thinking subject addresses itself, it addresses another insofar as it experiences the limits of itself by speaking to itself. Nancy observes that "the self is what does not possess itself and does not retain itself," and is, all told, what has "itself in this very same 'not' itself: nonsubsistence, nonsubstance, upsurge, subject."[91]

The self is the index of its own impossibility. Politics are only possible precisely because of this impossibility. Politics of the self are politics of the impossible are politics of the abyss are politics of the subject. Nothing is given, or nothing that is given is evident. Politics and thought are inventive practices that mistrust the given. They rebel against what is.[92] It does not aim to deny its factuality or contest its efficiency but rather generate itself as a vector of unrest, which tears down the existing. Politics contradicts facts by pointing to their inconsistency and arbitrariness. *Facts are*

MARCUS STEINWEG

nothing more than facts; politics begins with this assurance. Politics is the resistance to facts. That is why it only exists as progressive or leftist politics. Right-leaning politics isn't politics. It is the conservative administering of the factual order, while avoiding acknowledging its apoliticalness (and so it corresponds to that which Jacques Rancière calls the *police*).

There is no right-leaning thought. Active nonthought is what misunderstands itself as right-leaning thought: a depoliticized acceptance of the current socioeconomical situation (that is, political stagnation). The concept of affirmation—as affirmation of contingency—is opposed to the concept of acceptance. Politics and thought are affirmative not in their acceptance of the world as it is—that is, the understanding of affirmation held by (pseudo)critical attitudes, which believe in the opposition of affirmation and critique—but instead as affirmation of its level of inconsistency, which registers its contingency as the condition for the possibility of its otherness. What is political semiology if not the practice of analysis and questioning, but also the invention and activation of signs whose contingency and otherness is such that it counters constituted reality by denying it its authority?

SEX

Who would argue that sex circles an abyss? Even the most fulfilled sexuality bears witness that the subject never succeeds in reaching the consistency that will transport it

beyond the void. There is no reason to interpret this void as something negative. It enables the game of desire and pleasure.

EXILE

Thinking means allowing chaos exile within thought, which leads to new constructions in language and grammar. Thought beyond such contact with chaos wouldn't be thought at all. It would do nothing but repeat the familiar register.[93] That is why it entails breaking with thought, or at least breaking with its established form. Its aim is the invention of a new image of thought, as Deleuze called it. The only thought that counts drives toward the incommensurable, establishing itself at the point where its mathematics fails, its knowledge crumbles, its concepts dissolve, and its consciousness gets lost in the dark. That has nothing to do with romance. It is among thought's minimal requirements to itself to think more than it can think. Thus Nietzsche, Bataille, Deleuze, and Foucault, for example, emphasize the impossible, and insist on going beyond and intensity. Before we accuse them of transgression kitsch, we should try to imagine thought without this going beyond. It would assume the position of active nonthought. It would exhaust itself in spelling out the known and affiliating it with its manifest meaning. It would ensure rather than question the authority of sense and meaning, and would calm itself with the legitimation of a self-sustaining boredom.

Breaking with the regime of this boredom is what I call thinking.

HIATUS

The hiatus—the cleft, break, gap, difference, or opening—runs through the heart of all consistency, certainty, and convictions, and therefore also through the subject's heart.[94] The subject is that which builds a bridge over itself. The entity known as the subject only exists as the self-bridging subject. I call the subject that which attempts to consolidate itself throughout its lifetime by experiencing itself as hiatus. That's why living means constructing an architecture around itself, which by providing protection, defines the subject ex negativo as hiatus.

A QUESTION OF PERSPECTIVE?

The aim of philosophy was never to formulate perspectives about its era. Philosophy begins by refusing to be a question of perspective. It entails moving beyond the reactive and often-reactionary particularism of opinions and interests. We misjudge philosophical universalism if we don't understand that its violence is an *assertion*—not *proof* or *opinion* or *ideal*—which opposes the violence of relativism. Philosophical universalism doesn't have any aces up its sleeves. It reaches toward the unreachable and defends this lack of possessions as its only possible possession.

SUBOBJECT

In sex, the subject moves beyond itself and toward another by exposing itself as the object. By subjecting itself to exposure, it remains the subject.

ARROW

The narrator of F. Scott Fitzgerald's "The Crack-Up" leads a carefree life, which leads him to neglect his talents as an author:

> Life, ten years ago, was largely a personal matter. I must hold in balance the sense of futility of effort and the sense of the necessity to struggle; the conviction of the inevitability of failure and still the determination to "succeed"—and, more than these, the contradiction between the dead hand of the past and the high intentions of the future. If I could do this through the common ills—domestic, professional, and personal—then the ego would continue as an arrow shot from nothingness to nothingness with such force that only gravity would bring it to earth at last.[95]

To "hold in balance the sense of futility of effort and the sense of the necessity to struggle"—that could be the definition of artistic practice. To provoke failure doesn't imply wanting to fail. Desired failure isn't failure at all. It is the determination to resist the unavoidable nature of failure that makes its experience a delimiting reality. Suddenly a result

MARCUS STEINWEG

emerges, nearly a surprise or *event*, to put it in the terms of contemporary philosophy. It interrupts the economy of expectation as something that cannot be expected, generating a future without a past.[96] It indicates irreducible contingency. Openness to contingency is the condition for the possibility of artistic production. It demands release from the conductivity and authority of knowledge and memory. In his second untimely meditation, "On the Use and Abuse of History for Life," Nietzsche develops the idea that forgetting is part of taking action. That's also true of art. It implies a forgetting that approaches identification with a sort of zero level. One begins at zero, and does everything possible to make it so. One tries to begin at the beginning. There is no guarantee that it is possible. This lack of guarantee makes a possibility out of impossibility. Openness to contingency doesn't just mean being prepared for everything that might possibly come to pass during the work process. It implies the affirmation of impossibility as the condition for the possible as well as affirmation of failure as the condition for success and forgetting—the condition for artistic activity.

ARTWORK

The artwork is the theater of the subject's self-transcendence—a subject that does not refuse to assimilate itself into established realities in order to generate new forms, new concepts, and new thought.

JOURNEY

Only idiots cling to certainties, which they convince them-
selves are consistent givens. Art's affirmation of contin-
gency is the affirmation of the inconsistency of all
consistency, which (re)produces the system of established
aesthetic, political, social, and cultural values. Forgetting
doesn't mean denying the existence and efficiency of this
system. Forgetting means not bowing down to it, by taking
a step to the side and starting to stumble, giving in to a
motion whose direction isn't clear. Nietzsche's active forget-
ting can be articulated as directed drift or displacement. It
expresses the willingness to arrive someplace different than
intended. It marks a break with teleology. No ending is
inscribed within the beginning. No one knows where things
are heading. That is the shared experience of art and philos-
ophy: openness to the indeterminate, which takes authority
away from the past and present by placing trust in the
unknown.

SUSPENSION

The beautiful is not that which is given and known. We expe-
rience beauty at the borders of the given and known, where
meaning begins to slip and the senses fail. The experience
of the beautiful can be that intense as long as we do not
subsume into the beautiful that which is merely pleasing.
The pleasing exhausts itself in the aesthetic satisfaction
(*Wohlgefallen*) that Kant speaks of. That which is pleasing is

familiar and has been categorized. The beautiful scrapes at the surface of the pleasing. At the same time, it suspends all metaphysics of depth, together with their concomitant philosophy of innerness. The beautiful proves to be the border of the existing without evoking an absolute elsewhere.

DECONCENTRATION

We know how much destruction creation entails. We also know that you can't create anything if you aren't ready to give up control over your actions. But to whom? Certainly not, as romantic tradition and certain surreal traditions would have it, to a genius or daimon who guides the artist's hand.[97] It's much simpler and much less mysterious. There's no reason to associate the automatism of letting things happen with depth or the power of a secret creator. The mechanics of production don't demand much more than abstaining from the unconditional will of the creator. It demands the concentration of the artist-subject, which coincides with its deconcentration.

BADIOU WITH DERRIDA

In a decisive passage of his *Logique des mondes*, Badiou offered this formulation: "inexistance = différance."[98] What does it mean? The concept or nonconcept of *différance* is Derrida's term for the hole or absence or void or spatialization at the heart of the present. It is an opening and holding open that prohibits final closure and self-closure.

Analogous to Lacan's concept of the Real, *différance* marks the bone that catches in the subject's throat. While the traditional metaphysics of presence clings to the ideal of the self-identity of the human subject and its reality, the news about God's death or "Fehl," as Friedrich Hölderlin calls it ("being 'not there,'" in Christopher Middleton's translation), marks the tear in the present.[99] There is no complete self-presence, either for the subject or nonsubjective world. Suddenly something seems shattered. All certainties have fissured. What we called reality proves to be unreal and constructed. If it were still the objective of the classic metaphysics of self-constitution to stand the human subject on solid ground, to give its thought a teleological direction and bestow it with a horizon, that horizon is now cracked. The ground also proves to be full of holes. As Derrida would say, there is neither a consistent, undivided origin for the subject and its reality, nor is its future guaranteed to have meaning. Now there is only a hole and abyss. Ultimately, nothingness triumphs. *Différance* gives this nothingness a name. It makes room for it in reality. That is also the function of Lacan's real: to mark the efficiency of nothingness in being. Badiou's formula "inexistance = différance" can be interpreted as a homage to Derrida. (As we know, for a long time their relationship was more than problematic.) Its philosophical value consists in the equation of Derrida's term with his concept of inexistence (analogous to Derrida's *différance*, he writes *inexistance* with an *a* instead of *e*). Ultimately, inexistence is the inexistence of God. When God is

missing, so is all meaning. That is the open-horizoned situation of the *subject without subjectivity*, without God, without telos, without a fixed nature or given meaning or stable knowledge, and without ontological guarantees.

DESUBJECTIFICATION

The subject must escape itself to be itself. Its self does not lie within itself like an inner life or treasure. It realizes and constitutes itself in the moment of self-transcendence and desubjectification. "An experience is something you come out of changed," says Foucault.[100] That is why the moment of experience is linked to failure and crisis, but also to surprise and unforeseen happiness. That's why Foucault also speaks of a "border experience" and "desubjectification." Experience drives the subject to its limits. It touches its own border as if it were touching nothingness. Only in this way can it free itself from the temptation of narcissistic self-confirmation, by opening to the other in itself, by risking a voyage from nothingness to nothingness.

DECISION

The current version of capitalism is the capitalism of choice. We want to choose in order not to decide. The subject finds itself faced with countless options; choosing among them is what capitalism passes off as freedom. Freedom under capitalism is freedom to choose. But a decision breaks with the

system of given options. *Decisio* cuts through the texture of options, which is another name for the reality of facts. Today, reality presents itself as a system of choices. To decide, on the other hand, means not to choose from the given choices. It means placing the system of choice in question by choosing an (im)possibility that it has declared impossible. With every choice, the subject confirms the established texture of reality; with every decision the subject suspends it. *Krisis* is the ancient Greek word for decision as well as the situation that arises after a decision has been made. Today, the subject has been reduced to a consumer of choices. It negotiates its daily reality by choosing among the given alternatives. Thus, it ratifies the constituted sociopolitical reality. A decision opposes this reality. It opposes the instituted order through critical openness to its inconsistency and arbitrariness. While the subject stabilizes the given world order with each choice, deciding means importing disorder into it. But this import is not transport to the outside. Chaos already belongs to the order of facts as its implicit truth. That is the ideology-critical element of decision: to refuse to be enslaved to the world of facts, closing one's mind to their truth, as every subject necessarily does in the act of choosing.

EROS

To carry the articulation of passions to its extremes, where they begin to turn against themselves.

MARCUS STEINWEG

HURRAH-NEGATIVISM

Peter Sloterdijk's *Critique of Cynical Reason* commented on the sensibility of the founders of critical theory, "especially Adorno," "Its aesthetics ran just along the threshold of nausea toward everything and anything."[101] As if there could be a critique of sociopolitical realities, economic theology, factual scientific truths, religious hyperboles, cultural ideologies, and metaphysical dispositives based solely on a foundation of nausea at the world. As if nausea were the condition for and a symptom of critical philosophy. In fact, things haven't changed to this day, as if the starting point of ideological critique had to be overtly critical negativism. As if we hadn't read a line of Spinoza, Nietzsche, or Deleuze, to this day they believe that negativism is the *superior* foil to the "hurrah-optimism" that Adorno was right to question. Aren't things a bit more complicated than that? Wouldn't the complication of the simple opposition of optimism and pessimism, idealism and realism, and so on, be thought's minimal requirement for itself in order to be thought rather than the production of a clear conscience—that is, active nonthought?

TRANSGRESSION

It is a mistake to think that the dynamic known as transgression results from an act of will. The subject *as* subject is transgressive. It has gone far beyond its exterior, and has long inhabited it. The child who does something forbidden is

not transgressive. Truly transgressive: the subject that affirms itself as the theater of a going beyond that denies it all possibility of transgression a priori.

ANTIGONE

Antigone moves over the abyss of a void that is the absence of substantive security in a tradition, culture, or nature. As the empty-handed subject, she acts without recourse to arguments or laws. She owes her autonomy to this nakedness, of being a subject without hopes or a future.

THE OBSCURING OF EVIDENCE

The evident illuminates. It stands beyond question or discussion. In this sense, it is what stands outside thought. As such, it constitutes thought's true object. Think relates to something outside. It means to deprive the evident of its evidence, to refute its power and minimize its imperial nature. Philosophy entails resisting the light of evidence. Philosophy is the obscuring of evidence.

SUICIDE

In the horizon of late nineteenth- and twentieth-century thought, suicide is the truth of philosophy. The self has fallen into a cycle that corresponds to its obstinate questioning. There is no consistent self as a stable entity. Philosophy has never been anything but the thinking subject's

relationship to itself. Now we know that the self only exists as the theater of constant suicide. The subject is what constantly survives suicide.

INFINITESIMAL

An infinitesimal number is larger than zero and smaller than the smallest real number. The infinitesimal doesn't equal zero, yet nor does it belong to the order of real numbers. It indicates a value that belongs neither to the order of zero (nothingness) nor the order of the real numbers (reality). The infinitesimal subject is my term for the subject between the two orders, the intermediary subject between the order of the real and reality. Philosophy only exists as distance to reality, as *infinitesimal resistance*. Philosophy maintains its contact to the real by maximizing its proximity to it. In this maximizing, the object's objectivity emerges as the *real*. The object is that which opposes the subject. The object inscribes itself into the subject in the form of this opposition (Greek: *antíkeimei*). The object is already there. It does not stand in any posterior relationship to the subject. The object dimension can be defined as the space of true subjectivity. The subject lacks subjectivity because the dimension of objectivity (here, the indefinite nature of that which opposes the subject) determines its subjectivity. The subject skims this dimension by specifying its relationship to it. It always seeks to intensify contact with the incommensurable through assertions of form and language.

ONTOLOGICAL POVERTY

Capitalist logic is a logic of substitution that offers a plethora of substitutes to fill the void that the death of God left behind. The purpose of these substitutes is concealment. Philosophy can be defined as the unmasking of such masks, as long as it remains clear that no positive truth will appear behind the final mask. Nothing is behind it but nothingness, which indicates the absence of a final sense or transcendental meaning. Philosophy entails the affirmation of this absence, which overwhelms all valences and consistencies that constitute our reality with their ontological inconsistency. It's clear that this affirmation implies the critical interrogation of all certainties, which lend the subject its precarious stability. But it really is only on loan, pointing to the subject's ontological poverty (to the fact that nothing belongs to it outside of itself, not even itself, since all its life, that has been tangled up in obscure structures of ownership), rather than to the presentation of a proprietor operating on stable ground, as the metaphysics of final causes would suggest. The affirmative element of philosophy has nothing to do with acceptance of the sociopolitical status quo. It points to the inconsistency of fact worship that sees itself as critical even as it pursues a model of reality that it no longer questions. Affirmation is the affirmation of the inconsistency of *reality's* promise of consistency.

MARCUS STEINWEG

EQUALITY

It is not a contradiction to be both a subject and object at once. Kant's cleaving of the subject into receptivity and spontaneity (which Heidegger followed in his designation of Dasein as a *thrown projection*) is the merging of the dimension of the object with that of the subject, or to translate into older categories, the combination of the subject's finite and infinite natures. The idea of equality—and it certainly is just an idea—has its place in this cleft between the finite and infinite. It cannot be assimilated into the order of objective facts and the legalities that control them, or into the sphere of absolute sovereignty. It poses no contradiction to the subject's inequality with itself since it emerges from the rift that distances the subject from itself. Self-distance or self-difference constitutes the horizon of an equality that understands itself to be neither equalness nor equal making. In the horizon of equality, the subject identifies with the incommensurable, which interrupts every attempt at enclosing the self in a positive model of the ego. In its contact with the incommensurable, the subject experiences equality as a demand that correlates to the inequality of *itself* and its *ego*. The question of equality stirs up the fantasy of the ego, which can be considered the cardinal fantasy of Western metaphysics. It demands that the subject form a unit with itself that resists dissemination. Equality in the sense of self-sameness means building resistance against the subject's dispersive loss of self in the sphere of the nonsubjective, the realm of material, objects, history, or

becoming. In this realm, its self-address threatens to fail, meaning it might no longer know who is saying "I," even as it says "I," and who this could mean. It's clear what a precarious entity the subject who says "I" is, especially at the moment of this demand for unity and self-sameness, which owes its existence to knowledge of the impossibility of ontological closure, which is to say the impossibility of absolute knowledge.

SUN

Lacan's distinction between the three registers of the imaginary, symbolic, and real is based on the assured indiscernibility of the borders that are supposed to keep these zones discernible. Since he constantly revises his evaluation of these registers and their relationship to one another in his works, it is clear that the real evokes an inconsistency that threatens to obscure the other two registers. The imaginary and symbolic have the function of formulating a distance to the real. They imply a promise of consistency that can only be formulated as a distance to it. That's why one can say that the alliance of the symbolic and imaginary constitute our divided reality, while the real marks the nonintegral aspect of this reality, the platonic sun as *epekeina thes ousias*.

RIFT

Hegel was accused of downplaying the rift in identity into a certain negation. And yet it is precisely Hegelian thought

MARCUS STEINWEG

that is open to the abyss of negativity and to the rift in the heart of the subject—a rift that connects the subject to the incommensurable. The incommensurable abyss is not what the subject cannot reach. It is what it has always been in contact with. If we equate the incommensurable with the truth, then there are subjects who are uninterested in the truth, and yet truth exists only as that which no subject forgets. Hegel's decisive lesson was to insist on the obstinate, unforgetting nature of the truth rather than lamenting that we can't seem to update it in a process of anamnestic reappropriation. Truth doesn't need revitalization because it is never out of date insofar as it is what no one ever forgets.

DEFINITION

Philosophy in the singular doesn't exist. Philosophies exist. That is the first definition of philosophy: that it only exists in the plural, in order to endlessly complicate its definition. It entails the ever-advancing invention of philosophy. Philosophy is the invention of philosophy; hence its diversity. Deleuze defined it as the invention of concepts. In the first place, it is the invention of itself. Philosophy exists at the moment in which it generates a concept of itself. *What is philosophy*? There is no reason to only pose this question at the end of a philosopher's life. Analyzing and deconstructing its concepts belongs to the critical-affirmative character of philosophy. So does the affirmation and invention of a new self-conception. Critique is the critique of that which was and is. Affirmation affirms what could be and what does not

yet exist. Philosophy that does not entail both of these elements, the critical and affirmative, reflection and proflection, isn't philosophy at all. Let us risk the following sentence, which is analogous to a famous passage from Kant's *Critique of Pure Reason*: Critique without affirmation is empty; affirmation without critique is blind.[102] Within the concept of philosophy, critique and affirmation cooperate. Philosophy affirms itself as critical, even in its relation to itself. Philosophy only exists as the critique of philosophy. And yet it does not exhaust itself in negativity. It implies an affirmative element, which indicates its openness to the incommensurable, for which every philosophical position seeks to find a name.

THERE IS NO RIGHT-LEANING THOUGHT

Anyone who thinks is on the Left, which doesn't mean that everyone on the Left thinks. There is no right-leaning thought insofar as we call thought that which moves toward a nameless future instead of enclosing itself behind figures of the past. Those on the Right are obsessed with constructing a past whose function is limited to the suggestion of its necessity and stability. Those on the Right believe that there is such a thing as necessity and stability. To be on the Left is to abandon this belief. Those on the Left neither can nor want to believe, without forgetting that relinquishing belief occurs within the context of a certain kind of faith (one, as Wittgenstein demonstrated, of irreducible trust). Those on

the Left refuse the stupidity of believing that they believe nothing.

CELAN

Rather than a heroic act, *creatio* arises from constraint. "*Go with art into your innermost narrows. And set yourself free,*" Paul Celan gave expression to this constraint in his "Meridian" speech.[103] In the work of art, an arrogance is present: that of a subject who refuses to reduce itself to the possibilities represented in its field of possibility. Otherwise it would be an abject subject, since it wouldn't recognize things as options and freedoms that weren't actually so. The freedom of setting yourself free, of which Celan speaks, is another one entirely. It is the freedom of the subject in the objective lack of freedom made up of optional freedoms, which the authorities of fact pass off as alternatives. To go into your narrows means to oppose these alternatives, to search out the innermost corner of your possibilities, the edge of the zone of facts, and while running your hand along the wall of the impossible, see nothing more than these walls and narrows. Something like setting oneself free can only occur in the experience of blindness and aporia, in going beyond the options of freedom toward the impossible.

OUTSIDE

Truth can be defined as that which is beyond sense, as immanent transcendence, and as the index of ontological

inconsistency. In his seminar on Lacan from 1994–1995, Badiou defines psychoanalytic truth as that which is outside.[104] Analogous to and in conflict with the philosophical love of truth, the truth of psychoanalytic experience constitutes itself as the love of the integral beyond or outside, which Foucault as well as Deleuze, Derrida, and Blanchot affirm as thought's outermost vanishing point.

CONSENSUS

The rigor of all thought lies in its resistance to simplification, which threatens to pull it down before it can begin to ascend. Consensus cannot be the beginning of thought.

HYPERBOLE

Logos is openness to chaos. The logos subject is only *with* itself in that it is *outside of* itself. Its insanity and hyperbole is that it only exists as injury to itself.

REALITY

What we call reality is the sum of precarious facts, whose consistency we impute by seeing them as facts. But facts are nothing more than facts—which doesn't make them nothing. It means that just because something appears to be a fact, that doesn't make it consistent.[105] In any case, it lacks any final consistency. Our reality is a fabric composed of countless elements: fragile, transforming, porous

architecture; sensitive, permeable material; a cloth full of holes. If you look closely, it's coming apart at the seams. Suddenly it consists only of holes, linked to other holes. The pattern they form displays certain regularities. Structures repeat themselves. They perpetuate themselves by compromising one another. Consistency can only be provisional, constructed from a multiplicity of competing perspectives. A thousand gazes fragment and compose the space known as *reality*. In it, transparency and intransparency merge, as do consistency and inconsistency, order and chaos, light and darkness.

DIAPHORA

Agamben follows the fault line between concealment and unhiddenness, which Heidegger understands as the contentious mediation (*diaphorá*) of *lethe* and *aletheia*. In doing so, he considers the Heideggerian lethe as withdrawal (of being).[106] Being (the self) *is there* without being there. It marks the inconsistent character of the space of consistency that is *reality*, which Heidegger calls *the world*: the totality of everything that is. It's possible—like Agamben and Heidegger—to conceive of thought as entailing the compossibility of openness (aletheia) and closure (lethe). Every subject moves along the edge of this contentious compossibility. Its borderline is problematic because it remains indistinguishable. Things can be hidden and unhidden, transparent and intransparent, light and dark, and essent and nonessent all at once. Artistic thought is allied

with philosophical thought in its openness to the indistinguishable character of reality. Thus it is the aporetic thought of aporia. It is open to the dizzying experience of the compossibility of the noncompossible, and comprehends all that is, in that it must not necessarily be as it is. It affirms a sort of fundamental contingency. Contingent is what we call everything that could be different than it is. Contingent is also what I call that which is what it is, and yet is already different from that which it is. The self and other interfere in thought, whose contingency is heightened. Identity and difference intersect from the beginning. Reality is the space of this originary crossing. Lacan differentiates reality from the real in order to show that what we call reality is a figure of the repression of the real, or reality as real. The real is contingent and aporetic reality. Reality is the real minus its aporia and contingency. This is why we can say that reality marks a broken promise of coherency.

ACTIVE NONTHOUGHT

Adhering to established opinions is the subject's standby mode. It is the position of common sense, which trusts natural evidence. And from a political point of view, it is the position of reaction. One thinks without thinking, or one thinks only in order to think, while the activity known as thought is reduced to conformist nonthought. One affirms without knowing what and to what extent. One only believes that one knows, without knowing that all knowledge is based on belief. Thus one constantly engages in the

affirmation of the Heideggerian *Man* (the one). One thinks what *one* thinks instead of thinking *oneself*. One hardly thinks because *one is* the authority that recurs to *itself* as to a given self rather than exceeding the borders of self-containment. Active nonthought is the subject's normal status. It implies actively making the self passive. Thought that strives to be more than active nonthought must transcend its normality. Thought demands the active denormalizing of the thinking subject. One could also say that thinking means thinking against yourself. There is no thinking beyond a certain self-aggression.

BLINDNESS

Anyone who engages in artistic activity knows that production is ultimately blind. The artist moves toward the unknown. The same goes for philosophy: it must go beyond its knowledge in order to experience the inconsistency of its body of knowledge and lend expression to this experience. Art and philosophy exist only as precipitous overtaking of the self—a mad dash that allows the subject to advance beyond itself. But to where? Where it hasn't already been. It is progressive in precisely this sense. It affirms what it doesn't know.

WHY?

Why should I believe what I know?

MORAL

In representational systems (culture, language, society, history, and so on) that reduce its being to identity markers, the subject is only present as an absence. Identitary morality is precluded and combated by the singularity of life that eludes its norms. Morality is essentially reactionary.

ETHICS

A life is ethical if it abandons the realm of the livable for the unlivable.

VANITAS

Vanitas has been translated as "empty appearance," "nothingness," or "vain illusion." The theme of vanitas points to the finitude of human existence and futility of its concerns. The conflict of the finite and infinite, which reaches back before Christianity and permeates the whole of Western thought, is articulated in it. One must recognize that the subject participates in both orders, without being absorbed by either of them. It is the theater of the aporetic self-mediation of a finite subject with its incommensurable component parts. In vanitas, the finite reaches not only into idealizing thought's space of self-conception, which borders on the infinite. It generates the presence of the infinite (for death is of the order of the infinite, not life) or the incommensurable in the life of the subject, which is entangled in

its finite consistency. Hence, one could translate vanitas with *inconsistency*. This inconsistency persists in the midst of the universe of consistency that we call reality.

DEFINITION OF ART

What is a subject and to what degree does the work of art articulate its ontological structure? If the subject only exists as openness to the dimension of the nonsubjective, to the borders of subjective significance, whether through the unconscious, material, or history as a blind process, then the work of art is where it engages with the incommensurable, giving it a form that corresponds to the articulation of formless chaos. As Samuel Beckett says,

> How could the mess be admitted, because it appears to be the very opposite of form and therefore destructive of the very thing that art holds itself to be? ... What I am saying does not mean that there will henceforth be no form in art. It only means that there will be new form, and that this form will be of such a type that it admits the chaos and does not try to say that the chaos is really something else. The form and chaos remain separate. The latter is not reduced to the former. That is why the form itself becomes a preoccupation, because it exists as a problem separate from the material it accommodates. To find a form that accommodates the mess, that is the task of the artist now.[107]

Such forms always elude the imperatives of comprehensibility and communication by contradicting the prevailing fact obscurantism.

NAIVE THOUGHT?

Who is naive enough to think themselves beyond naïveté? Maybe it's naive to refuse to think, perpetuating a faith that may be either profane or religious. Maybe naïveté means not bothering with thought at all—that is, with the testing and probing of faith. Maybe it's not just for etymological reasons that we associate naïveté with a naturalness that can be maintained only at the cost of reflection. Of course it is the fantasy of the natural, of pristine innocence, and paradisiacal integrity. Does that mean that thought represents a break with this fantasy? It does insofar as it manages to cede space to it at its center. It isn't as if people are naive or think naively. Naïveté may be a name for the absence of thought, but thought does not guarantee the absence of naïveté. Is there naive thought, then? Yes, as long as this thought is understood to be the precise use of naïveté.

SEX WITH HEGEL

Whether we dream of the identity of identity and difference with Hegel, or the difference of identity and difference with Derrida, the difficulty is always keeping the two dimensions separate by relating them to each other. Sex could be a

MARCUS STEINWEG

name for the articulation of this difficulty, and not just in the physical sense.

BREATHING FREELY

Art and philosophy indicate the contingent nature of reality. They generate resistance against established realities and the dispositives that organize them. Their aim is not to flee from reality but rather to intensify contact with reality by maintaining a distance to it. Let us call this distance the subject's room to breathe freely. This room is subjective freedom in objective unfreedom—that is, the distance from the reality within it.

SPINOZA

Philosophy always unites the divided: the finite and infinite, fathomable and unfathomable, created and creator, Man and God. Whenever I think, my thought unites what must remain divided: immanence and transcendence.

GHOST

A ghost is present without being present. It is presence in the mode of absence. Hence, it represents a provocation to all ontologies, which differentiate between presence and absence, being and nothingness. Like Blanchot, Derrida analyzed ghostly presence in all the architectures of presence (personal identity, social relations, national substance,

institutional authority, political constructions, and so on). The ghost pierces a hole in what exists. It opens the texture of being to the nothingness implicit in it and drives the subject to its limits, where it forfeits coincidence with itself, hardly recognizing itself anymore. It begins to see itself as a ghost there, as a specter and phantom. The fact that "the other can appear only by disappearing" means that I meet myself as this other, who is already absent while in contact with me.[108] Present, slipping through my fingers; absent in the mode of presence. "The specter weighs [*pèse*], it thinks [*pense*], it intensifies and condenses itself within the very inside of life, within the most living life, the most singular (or, if one prefers, individual) life. The latter therefore no longer has ... a pure identity to itself of any assured inside."[109] The subject is torn out of itself. The ghost drives it out of its lair or interior, confronting it with an exterior that has always belonged to it. It confronts it with an exterior and absence, with nothingness whose place it has taken, as the representative of a self without a self or subject without subjectivity. Either this other takes my place or I am the one who takes its place—or both at once. The only certainty is that "I am riveted to this form, which I cannot contain."[110]

WRITING

More than a mystical act, writing is a mechanical one. Why do authors like Blanchot, Duras, and Heiner Müller insist that this activity has a sort of profane holiness?[111] Maybe because in the mechanics of writing, the subject exposes

itself to exteriority that tears it away from itself, the fantasy of itself, and the illusion of complete authorship. The freeing of the self expressed in writing has nothing to do with individual expression or creativity, nor with artistic esotericism. At this moment the self is delivered beyond the self, and the subject constitutes itself in the loss of itself.

GENTLE

Gentle thought approaches its objects uncompromisingly, allowing them to contradict its expectations rather than violently subjectivizing them with sympathy or the arrogance known as tolerance.

PANTHER

The fact that Kafka was "the solipsist without ipseity," as Adorno claims in *Minima Moralia*, implies that no one else described the fate of human beings as openness to the inexistent and proximity to emptiness.[112] Kafka doesn't say that it's enough to be *here*, like a restless animal or Rilke's panther, which dwells in the immanence of its cage. You have to get beyond the cage of immanence. As Wittgenstein says, "For all I wanted to do with them was just to go beyond the world and that is to say beyond significant language. My whole tendency and I believe the tendency of all men who ever tried to write or talk ethics or religion was to run against the boundaries of language. This running against the walls of our cage is perfectly, absolutely hopeless."[113] The fact that

it's hopeless doesn't make it avoidable. It means that wanting and tendencies and running against your own boundaries all entail the experience of an irresolvable aporia. Since I can't manage to meet with a stable self and make what is beyond language logical doesn't mean that I will stop trying, since trying reconciles me to the hopelessness of my intention. It is a reconciliation that is at odds with Hegel's speculative synthesis. It reveals the *conditio humana* as animality reaching out of itself into nothingness.

BACKGROUND

Georges-Arthur Goldschmidt once made a comment about Kafka that gets to the heart of things: "With Kafka, there is no background." He added that "the sentence says what it says and nothing else." It negates any "metaphysical emanation of background," as Reiner Stach put it. Kafka should be wrested from Max Brod's interpretation, which insinuates "religious thought" into his work, according to Goldschmidt.[114] But what does it mean that with Kafka, there is no background? Does it mean that there is no meaning or that only meaningless meaning exists? Like Wittgenstein, Kafka knows that our problems lie not with a lack of meaning but instead in its inconsistency.

REASON

Reason isn't reasonable. What we call modernity begins with the insight into the subject's excessive character. That's

why the sequence of events known as the postmodern—insofar as it expresses a certain decentrification, uprooting, dissemination, and contingency—does not supersede it but rather is compossible with it. All modernity is postmodern, but the inverse also holds true. We are only postmodern if we are modern. In other words (and here I am taking Nietzsche as a postmodern author), if we don't recognize the truth of Hegel in Nietzsche and the truth of Nietzsche in Hegel, we have not begun to think.

NIHILISM

As always, when nothingness and nonsense triumph over being and sense, we must keep in mind the Nietzschean difference between passive and active nihilism. While passive nihilism looks to nothingness to find motives for depressive sentimentality and narcissistic self-accusation ("I'm so empty, I'm so empty," "Everything is meaningless"), active nihilism recognizes an opportunity in nothingness. The fact that the subject is denied ultimate orientation denotes its freedom. A freedom, however, that it must claim within the immanence of the existing, in the space of codified facts—that is, in the universe of objective unfreedom.

EMOTION

There is a precondition for being touched by something: the subject must expose itself, including the affirmation of a certain violence—the violence of emotion. The subject's

difference, its singularity and diversity, is articulated in this violence. At the same time, like every feeling or thought, it is where a culture and convention expresses itself. There is neither emotion nor passion beyond stereotypes. No feeling, no thought that is authentic, integral, or intact. As always and everywhere, authenticity, singularity, and difference must assert themselves in the medium of the established, in the sociocultural ether of the feelings industry, which Eva Illouz calls "emotional capitalism."[115]

CRITICAL

Before he ultimately defined it as "the art of not being governed quite so much," in 1978 Foucault suggested that critique lay "on the outer limits of philosophy, very close to it, up against it, at its expense, in the direction of a future philosophy."[116] The same goes for philosophy. In order to pry itself away from academic boredom and absorption by the culture industry, philosophy is critical in precisely that sense. It already lies at its own limits, close to and completely against itself, at its own expense and in the direction of a future philosophy, which it anticipates. It exists only as self-critical practice that denies itself the trust and dependability of its instruments and methods by fighting for its self-confidence at the cost of constant self-suspicion. Its equal proximity and opposition to itself means that it only exists as an aporetic practice: restless, feverish, and heterogeneous. It only wins itself by losing itself. It wastes itself *in*

MARCUS STEINWEG

actu. It constantly risks itself. That means that philosophy may result in the loss of philosophy, or at least the loss of its current self-understanding. It can only approach itself by leaving itself in order to open up space for a future philosophy—a philosophy, to paraphrase Derrida, which remains future and never realizes itself entirely. Or thought, which as in Nietzsche and Heidegger, banks on the inauguration of a future "other-thinking" thought that remains irreducible to its ontotheological past. Philosophy is critical as thinking that is open to contingency, affirming the risk of self-transgression as a condition of its possibility.

SELF-LOSS

All of Duras's texts orbit the lack of identity. She answers the question "Who am I?" with "I was no one, with neither name nor face."[117] That isn't nihilism. Rather than being resigned or depressive, the identification of the subject with nothingness becomes the starting point for an (implicit) theory of self-inquiry in the wilderness of its desolation and indifference. "You have to trust yourself," says Duras.[118] Robert Antelme, Blanchot, and Agamben have developed a political-philosophical theory of the subject relatively close to Duras. The subject experiences itself only in contact with that which undermines its status as a subject (its "humanity" and self-containment)—in short, in the experience of self-loss.

HEGEL WITH KIERKEGAARD

What does it mean to think? From its beginnings, philosophy has asked itself this question. Varied though the answers may be, it seems clear that thought entails openness to a zone that is governed by factual codification. How does the subject move in this zone? What traces does it carry into it? What possibilities does it have to withdraw from it, even as it exposes itself to it? How much resistance is proper to philosophy, and how much assimilation to existing reality? How much resistance to the concept? Bernard Stiegler correctly emphasizes the "*existential* dimension of *all* philosophy, without which philosophy would lose all *credit* and sink into scholastic chatter."[119] What lends philosophy its relevance and makes it a feverish practice is not—and Stiegler does not claim—that it prefers the existential thinker Kierkegaard to the abstract philosopher Hegel but rather its status as the experience of the compossibility of abstraction and existence. The problem isn't that the positions denoted by the names *Hegel* and *Kierkegaard* can't be unified but instead that they are absolutely commensurable. Kierkegaard doesn't complete Hegel, nor does Hegel prepare for Kierkegaard. That would be the explanation offered by a philosophical-historical irenicism. It's more complicated than that. Hegel *is* Kierkegaard at the moment in which the one refuses to be the other.

MARCUS STEINWEG

religious—often contradicting our own self-image. To believe is to generate something from nothing. That is creativity—not God's creativity this time, but rather that of the believers who create him. Belief is by definition creative. The same is true of love: it creates its object from itself, in the motions of love. Even the blindest love creates images of the beloved. In love, one loves the images that one has made of the beloved, which are the vehicle to which the subject attaches the images that are generated of itself. The beloved other is nothing more than a surrogate entity for the imaginary love object. The beloved person indicates the abyss of their inexistence. Undoubtedly, they do not exist in the form they take within the horizon of love. Rather than confirming facts, they generate a presence that is never entirely of the present. The image generated of the beloved is more than an imaginary image because it breaks with the power of the imagination by affirming the appearance that it creates. Fantasy can be both illusion and appearance, with appearance marking an illusion that remains intrinsic to the reality of love. Reaching toward the other means making an image of them for oneself, which remains imaginary without being a delusion. Love bridges the abyss that distances the subject from the love object. That is its function: to mark this rift by overcoming it through the production of images. And so there are three types of metaphysics: religion, which creates its god by believing in it; the virtual economy, which creates value out of nothing; and love, which clings to appearance while claiming to be real. These three types of metaphysics share a sort of excessive creativity.

MARCUS STEINWEG

God, love, and money are forms of consistency that indicate their own inconsistency.[121] They are promises of consistency that cannot be kept. The same goes for reality. I call reality everything to which we assign consistency. Reality is synonymous with the space of facts, which Lacan called the *symbolic order*: the space of language, logos, and meaning pervaded by the imaginary. As the space of facts, I denote the universe of discursive facts and established meanings— that is, all things that can be confidently claimed to exist. The space of facts is the space of existing things. They may be objects, but they may also be ideas, opinions, hopes, and suspicions. Nonmaterial things are also facts that can be encountered as existing in the space of facts, and that circulate within it as memories, certainties, dreams, or fantasies, and therefore are constitutive of our reality. Reality is the space of facts populated by a diverse range of things and subject to innumerable encodings. Whether these encodings are also contingent or not, they exist in the mode of ontological efficiency.

NATURALLY?

Maybe sex is the privileged vantage point from which to measure the distance between the truth of humanity and our animality, to paraphrase Foucault.[122] At the same time, the fantasy of a prereflective innocence, which we associate with nature and animals, persists within it. It belongs to the subject's nature to touch on the construction of naturalness, which one convinces oneself is untouched by cultural affect.

CONSISTENCY

Lacan says that the beggar who thinks themselves a king is insane, but that the king who thinks themselves a king is insane as well.[123] Doesn't that mean that trusting in symbolic, arbitrary, ephemeral consistency implies a certain madness? Wouldn't openness to universal inconsistency be the best indication of reason? And what if reason pretended to be madness by promising to achieve a minimum of consistency through this openness?

IDEOLOGY

Ideological people are those who claim not to be.

IMMANENCE IDIOTS

Immanence idiots believe in fact. They don't see that referring to the consistent character of reality represents the dominant religion of our day. The subject would associate a conception of transcendence that is neither idealistic nor realistic with the inconsistency of its certainties. Transcendence doesn't point to some god. It indicates God's inexistence and marks the hole in the heart of immanence.[124] Immanence idiots trust the stability of immanence. They refer to Deleuze, betraying him. Deleuze wrote in Nietzsche's shadow and against him, and it is crucial to be the right kind of traitor. In this case, right means neither to do what is right nor defiantly do what is wrong. One must surpass the

MARCUS STEINWEG

system of rightness and wrongness, represented by the current order of reality, together with its stabilizing fantasies of substantial factual consistency. Those who believe that they can replace the transcendence described as religious or metaphysical with a religion of immanence are idiots.

DESIRE

Desire has a thousand names. It has earned none of them.

CONTEMPORARIES

Agamben associates the concept of contemporary figures with a dialectic of light and darkness: "The contemporary is he who firmly holds his gaze on his time so as to perceive not its light but rather its darkness."[125] Like the moment in Western and non-Western thought known as the Enlightenment, *le Siècle des Lumières, die Aufklärung*, illuminated reality has a way of obscuring its dark sides. Reality is the obscuring of reality. Agamben's *contemporary* is a critical position counter to the obscuring of reality known as *reality*. Consequently, being realistic doesn't mean clinging to reality in order to assure its consistency and coherence but instead letting go of it in order to catch sight of its darkness. I would refer to this realism that includes awareness of reality's unreality as *heightened reality*. It is a sort of realism that is critical to, not faithful toward, reality. It denies itself the option of subjugation to the authority of fact. This denial provides fodder for Agamben's evocation of the

contemporary as a figure of resistance. The truly contemporary person denies themselves the imperatives of the zeitgeist. It even questions questioning, which often leads to culturally conservative elitism. "The contemporary is the person who perceives the darkness of his time as something that concerns him, as something that never ceases to engage him," Agamben observes.[126] That makes them diagnosticians of their time who mistrust the diagnoses of their time. To mistrust one's time while intensifying one's relationship to it could be called thought. Art and philosophy do the same.

GROUND

Let's use the phrase *testing reality* to refer to reality's contact with thought that might be artistic, philosophical, or economic, as it experiences reality as a promise of consistency that is not kept. The real—as Lacan says—is not reality. It is reality—the universe of established certainties, evidence, and constants—insofar as it indicates reality's ontological uncertainty and fragility. Reality is the multifariously coded milieu of consistency that constitutes our divided world without any anterior world: the fragmentary, convention-based zone of facts, which lacks any foundation on an absolute ground.[127] It is not the now-ungrounded ground represented by our universe of logos—the domain of instituted horizons of sense and promises of meaning. The subject moves here as if across thin but not completely treacherous ice. The ice could break. In order to break, it

MARCUS STEINWEG

must first form a ground on which the subject can tread securely for a moment. Nietzsche's formulation about God's death bequeathed this fragmentary ground to the subject's experience of itself. Nietzsche consigned his future to a ground without grounds.[128] The fact that the ground is groundless makes it a flying carpet on which we hover over the abyss of ontological inconsistency. Reality is what I call that fabric of consistency that nonetheless allows for inconsistency, which Nietzsche labels the Dionysian abyss, Sartre the hole of freedom, Deleuze and Guattari chaos, and Lacan the real. Reality, in turn, is the index of its own fragility. In Wittgenstein's thought, it is addressed as a *language game* and *form of life*, and corresponds to what Lacan describes as *symbolic order*. The subject is embedded in reality as in a milieu without alternatives. Though there is no alternative to reality, it mustn't necessarily be as it is. The truth of reality is its historicity and contingency.[129]

NOTHINGNESS

What do I see when I look, in the moment at which I watch myself while looking, when my gaze clouds in order to see what only the blind see, the invisible? Apparently, seeing entails the transcendence of the gaze and excess of the eye. It always moves "at the edge of blindness."[130] It is constantly driven past its limits, stumbling or wandering about, and then marching with complete precision. Its exactitude seems due to an opening to the invisible. It borders on the limit of ocular evidence. Thus, it experiences its own

inconsistency and that of objects, comprehending that experience only happens blindly, as Heiner Müller says. Only by extending to cover its own incompetence does the gaze see anything. Only the overstimulated gaze has a chance at resisting the imperatives of light. The sun and death, says François de La Rochefoucauld in his famed *Maxims*, only allow themselves to come into focus at the cost of blindness. Nancy continues: "What thing *can* be looked at directly in the face? If looking something 'in the face' means seeing its 'truth' or 'evidence,' then there is never any direct face-to-face. Every face is a bedazzlement, terrible and marvelous."[131] To look things in the face, to see them as they are, is the demand placed on philosophical thought from Plato to Husserl. Which also means looking away from it in order to see it. This is abstraction: sight that is based on looking away. In order to see, I must be able to *not see*. I must trust in a blindness that gives sight. What does the blind person see? What is their object? I think that blind eyes open onto what is beyond the visible—a beyond that is earthly, in the midst of reality. The point is absolutely not to adhere to an absolute exterior. (The outside has long been inside, as psychoanalysis teaches us, as do Blanchot, Deleuze, Foucault, Derrida, and many more.) Nor is it the nowhere called utopia or some other paradise. The gaze that reaches into the invisible rubs elbows with nothingness.

DEFINITION OF ART

To answer formlessness with form, without neutralizing it.

ABSTRACTION

Abstraction exists only as concrete abstraction. Pure concretism—insofar as it's even imaginable—wouldn't be thought, nor would pure abstraction that abstains from all that is concrete. By concrete, I mean the individual or manifold singularities that are prior to abstraction's subsumption under a single concept. The concrete also always resists this subsumption. It is analogous to Adorno's nonidentical. As such, it evades the grasp of identifying thought, which *Negative Dialectics* associates with ontology.[132] The concrete is what cannot be generalized. It resists conceptual synthesis. Thus it confronts the conceptual work that is philosophical thought with its own limits. The concrete never cedes entirely to conceptualization. As the object of thought, the concrete is what escapes because it is always more than what generalizing abstraction sees in it. As Hegel argues, "Thought is *abstraction*, insofar as intelligence starts from concrete apperceptions, discarding one of the manifold definitions, underscoring another, giving it the simple form of thought."[133] One could say that blindness belongs to abstraction, as of every kind of sight. The fact that I don't see everything is a prerequisite for sight. The same goes for abstract thought. It must ignore some aspects of the object of thought in order to conceptualize it from the standpoint of certain criteria. This is why we speak of the reductive violence of abstract thought—that is, philosophy itself. Somewhere Hannah Arendt insists on the tyranny of the concept. We can also speak of the tyranny of abstraction, which

boils down to admitting that a certain violence is proper to thought. It is the violence of the reduction of complexity, as Niklas Luhmann says. Thought comes only at the cost of reducing complexity. When I simplify—and abstraction is simplification, as Hegel notes—I think. There is no thought without simplification because thought is the reduction of complexity through abstraction. What we call reality is excessively complex. Reality constitutes itself as an indefinite mass of concrete singularities whose totality remains unreachable to any kind of thought. Abstract thought sorts and orders and classifies subsets of this mass of singularities by concentrating on the individual rather than the whole. This concentration is what we call the reduction of complexity. Its opposite would be the deconcentration of the thinking subject in the ocean of endless singularities, which can hardly be called thought. Although—and because—simplification is part of abstraction, one shouldn't oversimplify the matter. To be against abstraction is to be against thought, to indulge in oversimplification with the clear conscience of those who believe themselves to be safely on the side of "hard facts" and empirical knowledge. But that just means favoring the quietism of nonthought to the struggles of thought—as almost everyone does almost all the time. Concretism does not want to think, and in fact, it doesn't, because it does not want to doubt the consistency of the facts that remain unreflected in its domain. Abstract thought is skeptical interrogation of the space of consistency, constituted by myriad inconsistent singularities, which we call our world. The moment of abstraction is the moment of

MARCUS STEINWEG

relinquishing the quietism of nonthought that clings to realities that remain constant for it as long as it does not think. Abstraction, on the other hand, is the extension of the self to reach inconsistency. Like speculation, abstraction communicates with an emptiness at the heart of reality. Abstraction also means questioning the consistency of our realities. And that is the definition of philosophy.

Abstraction communicates with nothingness, with the void, with the absolute known as the unconditional. As Nancy wrote in response to Hegel on the subject,

> Thought as thought of the absolute is nothing other than the heir of Kant. With the latter, reason came to know itself as the exigency of the unconditional. Or more precisely: as unconditional exigency of the unconditional—of which philosophy has become the observance and exercise. The refusal to give up on this exigency: this is Kant's thought repeated and taken over by all of his successors. Hegel intensifies it to its breaking point, sharpens it to the point of making it breach and tear apart every consistency in which the determination of a conditional entity retains itself.[134]

As contact with the unconditional, abstraction pushes the limits. It ignores the conditional and its consistency in order to reach its immanent unconditionality and inconsistency.

One could say that abstraction aims for a concrete absolute. To engage in abstraction doesn't mean to dream. On the contrary, abstraction interrupts the illusion that I call

concretism and skims the space of constituted realities in order to see beyond it. Skimming it does not mean turning away from it. It turns toward it. But it does not cling to the determinate or individual. It catches sight of the invisible, which we, like Hegel, call the absolute—an absolute that, as Nancy correctly notes, is "already there."[135] Far from being a metaphysical construction, the absolute names something distant that is present. Philosophy was never anything but the glimpsing and investigating of the immanent distance. Thus realism and idealism, immanence and transcendence, are false alternatives to it. Philosophical abstraction investigates a different sort of immanent transcendence. It is concrete abstraction.

Nietzsche spoke of the death of God, but of course also much earlier and actually really since its inception, philosophy has referred to a negative or absolute that reveals itself to be a void—a void or abyss. It is withdrawal from giving meaning, the disappearance of reality in the midst of reality, or reality. Reality that disappears into itself is what Lacan termed the real. It is an immanent exterior—not an external outwardness. To engage in abstraction is to ignore outwardness in order to catch sight of an exterior that is interior. Since it isn't easy, philosophy often overtightens the bow and the string snaps. Thought snaps under this excess tension and collapses into itself. But thought cannot avoid this danger. Thought entails the fact that it cannot depend on itself. It must free itself from itself in order to be thought. Thought that doesn't abandon itself would be nothing more than recapitulation of the already known. It does not stretch

MARCUS STEINWEG

toward anything new. Without curiosity, it remains completely self-possessed.

HETEROLOGY

Heterological thought defines itself via the other instead of itself. Heterology affirms the self as affirmation of the other. That makes it a rather-intricate affair. It or the other must remain irreducibly itself in order to be "itself." The self of the other must be another for me and my self. Countless aporias accumulate in this position from all dialectics, which allow the self to communicate with the other without resulting in a confluence of selfhood and otherness. A long-standing philosophical tradition reaching from Hegel to Adorno, Bataille and Derrida practiced heterological thought as an alternative to identifying or tautological thought. Barthes is correct to call tautology murderous. It defines the self through the self. What it excludes cannot be, even if it *is*. Tautological discourse becomes an escape maneuver: "One takes refuge in tautology as one does in fear, when one is at a loss for an explanation."[136] Tautology falls silent in the face of difference. Its helplessness is an expression of complexity eschewed. We recognize it in the behavior of "parents at the end of their tether [who] reply to the child who keeps on asking for explanations: 'because that's how it is.'"[137] Fear of the other articulates itself in tautology, as does the refusal of complexity. Those who want the same all over again argue tautologically ad infinitum. Tautology closes the pathway to an incommensurable

future. It is adoration of what is and what was. This makes it reactionary. You could say that it is the refusal to think instead of thought. It is heterology that opens itself to the foreign, which limits every self and individual a priori. Thinking is heterological because thought only exists if someone works up the courage to lose themselves in the indeterminate, other, and foreign. The agility of thought entails not knowing where it's leading you. Tautology, on the other hand, "creates a dead, a motionless world."[138]

GADAMER AND DERRIDA WITH HEGEL

Hans-Georg Gadamer is not heedless of difference, nor is Derrida preoccupied by it. The same goes for identity. Hegel *is already there*, like the tortoise waiting at the finish line for the hare. But Hegel does not stand primarily and exclusively for identity, as the widespread orthodoxy would have it. Hegel's entire project—beginning with *The Difference between Fichte's and Schelling's System of Philosophy*—is an expression of resistance against such orthodoxy. One might claim that philosophy first came into existence with this resistance. "Philosophy has always known and always practiced (even with Hegel, if we were to read him a little better) this exactness," writes Nancy, "which does not transform negativity, but which punctuates it, which pricks it or pins it on pages covered with our feverish writings, our discourses and our poems."[139] Exactness here means resistance to a model of dialectic that aims to eliminate

others, ultimately to part ways with them, is what you might call life—life that comes out of its shell in order to constitute itself in this meeting. Not as substance and immutable ego, but rather as an intersection with the contingency known as the *exterior*. Life as the experience of contingency, and as affirmation of what is neither known nor under control; life as journey or becoming instead of narcissistic confirmation of the self. The exterior has long been *within* the subject. It is part of it without belonging to it. One could speak of ghostly cohabitation or a phantom presence. In any case, it occupies the subject obstinately. It besets it from the beginning. Naturally it is excessive, but you might call its excess natural. It strains the body of the subject and drives it beyond itself. That is the subject's only purpose: to be incommensurable with itself. Hence its fever, nervousness, and unrest. Its lack of equilibrium. Its delirium and hysterical disposition. The only subject we can imagine is one in exile—an exterior subject, intimacy driven out of itself. Lacan called it extimacy, its interior dominated by the exterior. An exterior that determines its interior (from "a distance that is called proximity").[141] Its nature is to have no (unspoiled) nature. The contamination is primordial. It is always in contact with those foreign to it, since contact with itself entails contact with foreignness. It *is* this contact that constitutes it as the subject. The task of thought is to keep the subject in its fever, to think of it as a feverish entity. "Thought," writes Nancy with Hegel in mind, "must take the self out of itself; it must extract it from its simple being-in-itself: thought is itself such an extraction, along with the speech in which

MARCUS STEINWEG

thinking takes itself out of itself and exposes itself."[142] The self-exposition of thought describes its opening to its exterior, to the domain of a rootlessness that interrupts the fantasy of a self-possessed ego at rest in its identity.

The subject is hyperbolic and excessive. It is unstable from the start. Apparently Nancy has this instability in mind when he writes that it is "a question of opening mere reason up to the limitlessness that constitutes its truth."[143] The possibilities of reason and its acts are not limitless. Reason is limited by the limitless (which is precisely what Kant says). In this sense, limitlessness marks a sort of closure. As closure, it reaches into the most interior precincts of the subject.[144] It constitutes this precinct by delimiting and restricting it. The limitless limits the reasoning subject beyond its capacities. Hence its fever, its unrest, and the pain that makes its identity smolder. It marks the rift that traverses it, compromising its self-identity. The rift opens up the space of its problematic meeting with itself or ghostly identity. Like a border, it divides a territory. It cuts through the subject and its body. It explodes it. It falls apart because it is nothing but its own falling apart or the motion of ongoing self-deconstruction. One might call it excess, turbulence, and the experience of inconsistency. One could also speak of its conflict or primordial distraction. It's clear that Adorno's concept of the nonidentical, Lacan's split subject, Derrida's différance, Deleuze's chaos, and so on, refer to this rift despite the differences between their philosophical projects. It is another name for the inexistence of God. Nietzsche's thought on this inexistence opens thought's

space of unrest. It itself is restless and feverish. It consti-
tutes "a deed, which thus ceaselessly goes wild with rage or
excitement and vacillates uncertainly between exaggeration
and pain."[145] Hence Deleuze can call Nietzsche a thinker who
"dramatizes" ideas (he put the word in quotation marks),
and ultimately, the point is a dead god at all "levels of ten-
sion."[146] God's death leaves behind a hole that can hardly be
filled, which doesn't mean that the subject isn't prepared to
do anything and everything to replace God with some sort of
prosthesis. Maybe that's what religion is: a god ersatz rather
than his affirmation. Nothing seems more difficult today
than to be nonreligious. Especially in the position that calls
itself *atheism*. Modern-day atheism follows a logic of sub-
stitution, which seeks a replacement for the authority
known as God. As long as something takes his place—
success in symbolic frameworks, money, or power, but also
spiritual fetishism, esotericism, moralizing, and so on—his
inexistence is tolerable. That is, until you start to think. In
Nietzsche and Philosophy, Deleuze writes, "The places of
thought are the tropical zones frequented by the tropical
man, not temperate zones or the moral, methodical, or
moderate man."[147] Tropical fever causes humans to border
on their borders. It confronts them with the ontological
inconsistency of their reality. They realize that there is no
transcendental sense, no absolute meaning. They recognize
themselves as the subject stumbling through the desert of
their ontological desolation. They are tropical vagabonds.
Their bodies shudder with chill. Incommensurable impulses
convulse them. In a fever, they face the truth of their thought.

MARCUS STEINWEG

It is the truth of an inconsistent agent whose activities are the result of passive affect (which Spinoza taught us). Beset by them, the subject collides with the walls of itself. It recognizes that it is populated by forces that dominate it. It is the theater of this experience. The subject deconcentrates itself in it. It contracts by surrounding its emptiness like a closed fist. This embrace of nothingness is not nothing. It marks the act of powerless self-affection. The self that affects itself is the agent of its emptiness. As Heidegger says, it identifies itself as "a lieutenant of the nothing."[148] At its highest point of density—in a moment of rigorous self-concentration—the subject understands itself as a subject without subjectivity. Which also means that it is a subject without God, nature, or essence, without telos or plan. It is neither a sovereign conceptual operator nor self-assured cogito, neither omnipotent nor omniscient. Rather, it is the theater of the feverish self-mediation with nothingness, which Lacan calls the real, and Nietzsche the chaos or desert.

DOING NOTHING

Who doesn't dream of the ease of an act that consists of doing nothing? Who never dreams the dream of active immobility or agile passivity?

Notes

1. Georges Bataille in conversation led by Georges Charbonnier, France Culture, January 14, 1959. See also Johan Huizinga, "Ernst und Spiel," in *Das Spielelement der Kultur*, ed. Knut Ebeling (Berlin: Matthes & Seitz, 2014), 75–111.

2. "We hear today," Giorgio Agamben states in a seminar from 1979–80, "that knowledge (in its pure form: as mathematics) has no need of foundation. That is certainly true if, with inadequate representation, we think of foundation as something substantial and positive. But it is no longer true if we conceive of foundation as it is in the history of metaphysics, that is, as an absolute, negative foundation. See Giorgio Agamben, *Language and Death*, trans. Karen E. Pinkus with Michael Hardt (Minneapolis: University of Minnesota Press, 1991), 98 (footnote). Originally published as *Il linguaggio e la morte* (Turin: G. Einaudi, 1982).

3. Daniel Heller-Roazen, *The Fifth Hammer* (Brooklyn: Zone Books, 2011), 40.

4. Bataille in conversation led by Charbonnier.

5. Georges Bataille, *Henker und Opfer* (Berlin: Matthes & Seitz, 2008), 111.

6. Bataille in conversation led by Charbonnier.

7. Ibid.

8. Giorgio Agamben. *Qu'est-ce que le commandement?* (Paris: Payot et Rivages, 2013), 20. See also Jacques Derrida, *Archive Fever*, trans. Eric Prenowitz (Chicago: University of Chicago Press, 1995), 1. Originally published as *Mal d'Archive* (Paris: Galilee, 1995): "Arkhē we recall, names at once the

commencement and the commandment. This name apparently coordinates two principles in one: the principle according to nature or history, there where things commence—physical, historical, or ontological principle—but also the principle according to the law, there where men and gods command, there where authority, social order are exercised, in this place from which order is given—nomological principle."

9. Ludwig Wittgenstein, *On Certainty*, ed. G.E.M. Anscombe and G. H. von Wright, trans. Denis Paul and G.E.M. Anscombe (Oxford: Blackwell, 1969), no. 471. Originally published in German as *Über Gewißheit* (Frankfurt am Main: Suhrkamp, 1970). See also Hannes Böhringer, "Ach die Philosophie!" in *Inaesthetics 5: Philosophy!* ed. Wilfried Dickhoff and Marcus Steinweg (Berlin: Merve, 2014), 92: "The beginning slips out of the concept's grasp. The beginning is a crazy story if it is one at all."

10. See Marcus Steinweg, *Behauptungsphilosophie* (Berlin: Merve, 2006). Alain Badiou claims that like the Greek sophists, Wittgenstein insisted "that the rules are the 'basis' of the thought," which "inevitably discredits the value of truth." This is only true if you misinterpret the truth as something given rather than viewing it as the implicit abyss of any basis or language game. See Alain Badiou, "Of an Obscure Disaster," *Laconian Ink* 22 (September 2003): 82.

11. Jacques Derrida, *Monolingualism of the Other: or, The Prosthesis of Origin* [Cultural memory in the present], trans. Patrick Mensah (Stanford, CA: Stanford University Press, 1998), 21. Originally published as *Le monolinguisme de l'autre: ou la prosthèse d'origine* (Paris: Galilée, 1996).

12. Wittgenstein, *On Certainty*, no. 177.

13. Ibid., no. 166.

14. As resistance that cannot be internalized, the real marks the "inherent inconsistencies" of the symbolic space of

consistency that we call reality. See Slavoj Žižek, *The Parallax View* (Cambridge, MA: MIT Press, 2006), 28.

15. Michel Foucault, *The Order of Things* (New York: Pantheon, 1970):

 [I]t is historicity that, in its very fabric, makes possible the necessity of an origin which must be both internal and foreign to it: like the virtual tip of a cone in which all differences, all dispersions, all discontinuities would be knitted together so as to form no more than a single point of identity, the impalpable figure of the Same, yet possessing the power, nevertheless, to burst open upon itself and become the other.

16. Deleuze speaks of the "relation to the inhumane within the [human] self-relation. See Gilles Deleuze, *Dialogues II*, trans. Hugh Tomlinson and Barbara Habberjam (New York: Columbia University Press, 2007), 151.

17. Michel Foucault, *The History of Sexuality, Vol. 3: The Care of the Self*, trans. Robert Hurley (New York: Random House, 1986), 216. Originally published as *Le Souci de soi* (Paris: Gallimard, 1984).

18. Compare Jean-Luc Nancy, *L'extension de l'âme* (Strasbourg: Le Portique, 2003), 29: "The body that is commingled with itself and with another (or others), that is commingled with itself *just like* it is commingled with another enters neither a state of identification nor confusion, but rather into an unsettling nearness. Unsettling because it is near, nearing an uncertain decision and renewal, repetition, and revival of distance, and desire consist of relishing its ever uncertain, labile, trembling dimensions."

19. Gilles Deleuze, *Negotiations*, trans. Martin Joughin (New York: Columbia University Press, 1995), 150. Originally published as "Conversation with Raymond Bellour and François Ewald," *Magazine Litteraire 257* (September 1988), collected in *Pourparlers* (Paris: Minuit, 1990).

20. Like Deleuze, Byung-Chul Han reminds us that one must differentiate between idiocy and stupidity: "From the outset, philosophy has been closely associated with idiocy. Every philosopher who has produced a new vernacular, a new language, or a new way of thinking must necessarily have been an idiot." Byung-Chul Han, *Psychopolitik: Neoliberalismus und die neuen Machttechniken* (Frankfurt am Main: S. Fischer, 2014), 107.

21. Paul Veyne, *Foucault, sa pensée, sa personne* (Paris: Albin Michel, 2008), 69. On the same subject, Deleuze says: "Paul Veyne paints a portrait of Foucault as a warrior. Foucault always evokes the dust or murmur of battle, and he saw thought itself as a sort of war machine. " Deleuze, *Negotiations*, 103. Foucault questions the "model of war" and its parasitic relationship to discussions of political themes. See Michel Foucault, *Remarks on Marx*, trans. R. James Goldstein and James Cascaito (New York: Semiotext[e], 1991), 180. Originally published as *Colloqui con Foucault* (Salerno: 10/17 cooperativa editrice, 1981).

22. Deleuze, *Negotiations*, 150. "Whenever a great thinker dies, idiots feel a sense of relief" (ibid., 84).

23. Ibid., 103.

24. See Jacques Derrida, "Violence and Metaphysics," in *Writing and Difference*, trans. Alan Bass (Chicago: University of Chicago Press, 1978), 179ff. Originally published as *L'écriture et la différence* (Paris: Seuil, 1967).

25. Compare Jacques Derrida, *Of Grammatology*, trans. Gayatri Chakravorty Spivak, fortieth-anniversary ed. (Baltimore: Johns Hopkins University Press, 2016). Originally published as *De la grammatologie* (Paris: Minuit, 1967).

26. Derrida began his first seminar at the École normale supérieure with the remark that the existential question must be divorced from ontology because it culminates in a "*destruction* of ontology." See Jacques Derrida, *Heidegger: The*

Question of Being and History, trans. Geoffrey Bennington (Chicago: University of Chicago Press, 2016), 1. Originally published as *Heidegger: la question de L'Etre et l'Histoire* (Paris: Galilée, 2013).

27. Niklas Luhmann, *Archimedes und Wir* (Berlin: Merve, 1987), 118.

28. Compre Étienne Balibar, *La crainte des masses* (Paris: Galilée, 1997).

29. Jean-Luc Nancy, *La pensée derobée* (Paris: Galilée, 2001), 99.

30. Compare Derrida, *Of Grammatology*, 28.

31. Compare to Peter Sloterdijk, quoted in *Tages-Anzeiger*, March 14, 2015: "No one has the right to remain free from insults, and certainly no one is entitled to sensitivity. Were such a right to exist, it would unleash malicious competition among the sensitivity collectives. Everyone subject to an insult would claim for themselves the right to be even more sensitive than the others."

32. Martin Heidegger, *Schelling's Treatise on the Essence of Human Freedom*, trans. Joan Stambaugh (Athens: Ohio University Press, 1985), 155. Let us remember that in *Being and Time*, Heidegger already speaks of "Dasein's transcendence." An important elucidation of the transcendence problem is to be found in the Marburg lecture from summer semester 1928 in Martin Heidegger, *The Metaphysical Foundations of Logic*, trans. Michael Heim (Indianapolis: Indiana University Press, 1984), 185. Originally published as *Metaphysische Anfangsgründe der Logik im Ausgang von Leibniz* (Frankfurt am Main: Verlag Vittorio Klostermann, 1978).

33. Compare Martin Heidegger, *The Fundamental Concepts of Metaphysics*, trans. William McNeill and Nicholas Walker (Indianapolis: Indiana University Press, 1995), 177–178, sec. 42. Originally published as *Die Grundbegriffe der Metaphysik* (Frankfurt am Main: Verlag Vittorio Klostermann, 2004).

34. Karl Jaspers was insistent that with Nietzsche, the objective of overcoming remains obscure, "the final word is spoken never and nowhere." Karl Jaspers, *Nietzsche and Christianity* (Washington, DC: H. Regnery Company, 1961), 102. Originally published as *Nietzsche und das Christentum* (Hameln: F. Seifert, 1946).

35. Jean-Luc Nancy and Daniel Tyradellis, *Was heißt uns Denken?* (Zurich: Diaphanes, 2013), 74. See also Jean-Luc Nancy, *Ego sum* (Paris: Flammarion, 1979). Maurice Blanchot speaks of the "endless restlessness" of a subject "excluded from the promised land of truth." Maurice Blanchot, *The Book to Come*, trans. Charlotte Mandell (Stanford, CA: Stanford University Press, 2003), 148. Originally published as *Le livre à venir* (Paris: Gallimard, 1959).

36. Friedrich Nietzsche, *The Gay Science*, trans. Walter Kaufmann (New York: Vintage, 1974), 181. Originally published as *Die fröhliche Wissenschaft* (Chemnitz, 1882). Sloterdijk comments on this passage, "emphasizing that the pro forma equivalent enumeration of the types of plunging 'backward,' 'sideward,' 'forward,' and 'in all directions,' only represent epiphenomena of the 'forward' plunging type. Here, 'forward' means away from the old 'center of security,' away from the conditions, standards, and solid foundation that once was. If plunging and precipitousness are one and the same, then god is dead in the machinations of this motion." Peter Sloterdijk, *Die schrecklichen Kinder der Neuzeit* (Berlin: Suhrkamp, 2014), 72. On precipitousness as the modality of the subject, see Marcus Steinweg, *Philosophie der Überstürzung* (Berlin: Merve, 2013).

37. Slavoj Žižek, *The Indivisible Remainder* (London: Verso Books, 1996), 20.

38. Heidegger distinguished between the abandonment of being by being (*Seinsverlassenheit des Seins*) and forgetfulness of being by (human) Dasein (*Seinsvergessenheit des [menschlichen] Daseins*). See Martin Heidegger, *Contributions to*

Philosophy (Of the Event), trans. Richard Rojcewicz and Dan-iella Vallejo-Neu (Indianapolis: Indiana University Press, 2012). Originally published as *Beiträge zur Philosophie* (Frankfurt am Main: Suhrkamp, 1989).

39. These positions are united in their attempt to integrate "the moment of horror into their thought." Armen Avanessian and Björn Quiring, *Abyssus Intellectualis* (Berlin: Merve, 2013), 12.

40. Quentin Meillassoux writes in "L'inexistence divine," in *Failles No. 3: Existence Inexistence* (Paris: Éditions Nous, 2014), 55: "If nothing presides over earthly law and nothing watches over earthly proceedings, then its laws aren't laws at all. They do not rule over the process of becoming, but rather they themselves are ruled over by a lawless becoming. There is no reason for them to last forever." Original: "Si rien n'existe au-delà des lois du monde pour gouverner le monde, c'est que ces lois n'en sont pas; qu'elles ne gouvernent pas le devenir, mais sont gouvernées par un devenir sans loi; qu'elles n'ont pas de raison de durer toujours."

41. Ludwig Wittgenstein, *Tractatus Logico-Philosophicus*, trans. C. K. Ogden and Frank P. Ramsey (London: Keegan Paul, 1922), 6.44. Originally published as *Tractatus Logico-Philo-sophicus*, in *Annalen der Naturphilosophie* 14 (1921).

42. Ludwig Wittgenstein, "A Lecture on Ethics," trans. Max Black, *Philosophical Review* 74, no. 1 (1965): 3–12. Originally published as "Vortrag über Ethik" (1930).

43. Frédéric Neyrat, *Le communisme existentiel de Jean-Luc Nancy* (Paris: Éditions Lignes, 2013), 40.

44. Jean-Luc Nancy, *Adoration: The Deconstruction of Christianity II*, trans. John McKeane (New York: Fordham University Press, 2012), 33. Originally published as *Déconstruction du christianisme: Tome 2, L'Adoration* (Paris: Editions Galilée, 2010).

45. Jaspers also came to the conclusion "that the world contained no reason for itself within itself" because it "cannot be inferred"

as a point of philosophical existence: "Being is torn. No solid ground can be secured for ultimate knowledge of being within the whole. We would like to see it, to oversee it, to possess it in an ontology. But just as we grasp it, it crumbles." Karl Jaspers, *Von der Wahrheit* (1947; repr., Munich: Piper, 1991), 873.

46. Jean-Luc Nancy and Daniel Tyradellis, *Was heißt uns Denken?* (Zurich: Diaphanes, 2013), 17.

47. Jean-Luc Nancy, *Hegel: The Restlessness of the Negative* (Minneapolis: University of Minnesota Press, 2002), 5. Originally published as *Hegel: L'inqiétude du négatif* (Paris: Machete Littératures, 1997).

48. Ludwig Wittgenstein, *Culture and Value*, ed. Georg Henrik von Wright, trans. Peter Winch (1931; repr., Chicago: University of Chicago Press, 1980), 17e. Originally published as *Vermischte Bemerkungen* (Frankfurt am Main: Suhrkamp, 1977).

49. Roland Barthes, *The Responsibility of Forms*, trans. Richard Howard (New York: Farrar, Strauss and Girous, 1985), 173. Originally published as *L'obvie et l'obtus* (Paris: Editions du Seuil, 1982).

50. Ibid., 167.

51. See Heidegger's 1968 seminar in Le Thor: Martin Heidegger, *Four Seminars*, trans. Andrew Mitchell and François Raffoul (Bloomington: Indiana University Press, 2003), 10ff. Originally published as *Vier Seminare* (Frankfurt am Main: Verlag Vittorio Klostermann, 1977).

52. Marguerite Duras, *Le Monde extérieur* (Paris: P.O.L., 1993), 24.

53. Jacques Lacan, *The Seminar of Jacques Lacan: Book VII, The Ethics of Psychoanalysis*, ed. Jacques Alain-Miller, trans. Dennis Porter (New York: W. W. Norton, 1997), 124–125.

54. Conversation with Madeleine Chapsal in *L'express*, no. 310, May 13, 1957.

55. Giorgio Agamben, *Language and Death*, trans. Karen E. Pinkus and Michael Hardt (Minneapolis: University of Minnesota Press, 1991), xiii. Originally published as *Il linguaggio e la morte* (Turin: G. Einaudi, 1982).

56. In fact, Heidegger refers to the event (*Er-eignis*) represented by the fusion of being and (human) Dasein as a "self-suspended structure." Martin Heidegger, *Identity and Difference*, trans. Joan Stambaugh (Chicago: University of Chicago Press, 2002), 38. Originally published as *Identität und Differenz* (Pfullingen: Neske, 1957).

57. Michel Foucault, *Speech Begins after Death*, trans. Robert Bononno (Minneapolis: University of Minnesota Press, 2013), 53. Originally published as *Le beau danger* (Paris: Éditions de l'École des Hautes Études en Sciences Sociales, 2011).

58. Michel Foucault, *The History of Sexuality, Vol. 2*, trans. Robert Hurley (New York: Random House, 1985), 8. Originally published as *Histoire de la sexualité II: L'Usage des plaisirs* (Paris: Gallimard, 1984). On the conception of the human being as a madman, see Giorgio Agamben, "Bartleby, or On Contingency," in *Potentialities* (Stanford, CA: Stanford University Press, 1999); Rainer M. Kiesow, *Das Irrsal hilft*, ed. Henning Schmidgen (Berlin: Merve, 2004).

59. René Aguigah, "Der Atheismus ist das wahre Christentum," in *Cicero: Magazin für politische Kultur*, accessed October 21, 20216, http://www.cicero.de/salon/der-atheismus-ist-das-wahre-christentum/44813.

60. Nancy, *La pensée derobée*, 148.

61. Guy Debord, *The Society of the Spectacle*, trans. Fredy Perlman and John Supak (Detroit: Black and Red, 1977), sec. 167, 77. Originally published as *La Société du Spectacle* (Paris: Buchet-Chastel, 1967).

62. Louis Althusser, *For Marx*, trans. Ben Brewster (London: Verso, 2005 (1969), 243. Originally published as *Pour Marx* (Paris: François Maspero, 1965).

63. Heiner Müller, *Gespräche 2: 1987–1991*, vol. 11 (Frankfurt am Main: Suhrkamp, 2008), 412.

64. Jacques Derrida, *Points ... : Interviews, 1974–1994*, ed. Elizabeth Weber, trans. Peggy Kamuf (Stanford, CA: Stanford University Press, 1995), 219–220.

65. See Heidegger's February 15, 1972 letter to Hannah Arendt in *Hannah Arendt and Martin Heidegger, Letters, 1925–1975*, trans. Andrew Shields (New York: Harcourt, 2004), 190ff. Originally published as *Briefe 1925–1975* (Frankfurt am Main: Verlag Vittorio Klostermann, 1999).

66. Gilles Deleuze, "How Do We Recognize Structuralism?" in *Desert Islands and Other Texts*, ed. David Lapoujade, trans. Mike Taormina (Los Angeles: Semiotext[e], 2004), 192. Originally published as "A quoi reconnaît-on le structuralisme ?" in *Histoire de la philosophie VIII. Le XXe siècle*, ed. F. Châtelet (Paris: Hachette, 1973).

67. Slavoj Žižek, *The Metastases of Enjoyment* (London: Verso Books, 1994), 57.

68. Maurice Blanchot, *The Space of Literature*, trans. Ann Smock (Lincoln: University of Nebraska Press, 1989), 263. Originally published as *L'espace littéraire* (Paris: Gallimard, 1955).

69. Wittgenstein, *Culture and Value*, 83.

70. Yves Bonnefoy, *Le Lieu d'herbes* (Paris: Galillée, 2011), 53–54.

71. Wittgenstein, *Culture and Value*, 42e.

72. Roland Barthes, *Roland Barthes by Roland Barthes*, trans. Richard Howard (New York: Farrar, Straus and Giroux, 1977), 85. Originally published as *Roland Barthes par Roland Barthes* (Paris: Editions du Seuil, 1975).

73. Jean-Luc Nancy, *L'Intrus* (Paris: Galilée, 2010), 43.

74. Alain Badiou, *Briefings on Existence: A Short Treatise on Transitory Ontology*, trans. Norman Madarasz (Albany: SUNY Press, 2005), 24. Originally published as *Court traité d'ontologie transitoire* (Paris: Editions du Seuil, 1998).

75. Jean-Luc Nancy, *Intoxication*, trans. Philip Armstrong (New York: Fordham University Press, 2016). Originally published as *Ivresse* (Paris: Editions Payot & Rivages, 2013), 40.

76. See also Maurice Blanchot, *The Step Not Beyond*, trans. Lynette Nelson (Albany: SUNY Press, 1992); Jean-Luc Nancy, *Adoration: The Deconstruction of Christianity II* (New York: Fordham University Press, 2012). Originally published, respectively, as *Le pas au-delà* (Paris: Gallimard, 1973); *L'Adoration* (Paris: Galilée, 2010).

77. Martin Heidegger, *Being and Time*, trans. Joan Stambaugh, rev. ed. (Albany: SUNY Press, 2010), 183. Originally published as *Sein und Zeit* (Tübingen: Niemeyer, 1953): *"Not-being-at-home must be conceived existentially and ontologically as the more primordial phenomenon."*

78. "'Perfection,'" Adorno says, citing Nietzsche, "'must not have become,' that is, it should not appear made." Theodor W. Adorno, *Minima Moralia*, trans. E.E.N. Jephcott (1951; repr., London: New Left Books, 1974), 226.

79. Compare Immanuel Kant, *Critique of Pure Reason*, ed. and trans. Paul Guyer and Alan Wood (Cambridge: Cambridge University Press, 1998), B89. Originally published as *Kritik der reinen Vernunft* (1781).

80. Roland Barthes, *Empire of Signs*, trans. Richard Howard (New York: Hill and Wang, 1982), 9. Originally published as *L'empire des signes* (Geneva: Editions d'Art Albert Skira, 1970).

81. Compare Marcus Steinweg, "Wittgensteins Tier," in *Inaesthetics 2: Animality*, ed. Wilfried Dickhoff and Marcus Steinweg (Berlin: Merve, 2011), 42–49.

82. See Roland Barthes, *Mythologies*, trans. Richard Howard (New York: Jonathan Cape, 1972). Originally published as *Mythologies* (Paris: Editions du Seuil, 1957).

83. Analogous to Barthes's correlation of semiology and structuralism, we can speak of a structuralism of contingency, which corresponds to that which Barthes describes as the

hallmark of Jules Michelet's writing, whose poetic (or open) structure remains connected only to "holes." See Roland Barthes, *Michelet*, trans. Richard Howard (New York: Farrar, Straus and Giroux, 1987), 5–25. Originally published as *Michelet par lui-même* (Paris: Editions du Seuil, 1954).

84. Compare Nancy, *La pensée dérobée*, 19: "If the power of myth (or of the figure) could consist in providing grounds, then the objective would be to think of the myth (*mûthos*, speech) of *logos* as the endless grounds, as the absence of grounds, and as (de)grounding [*(dé)fondation*] through the withdrawal of grounds."

85. Roland Barthes, *Elements of Semiology*, trans. Annette Lavers and Colin Smith (New York: Hill and Wang, 1968), 35. Originally published as *Éléments de sémiologie* (Paris: Editions du Seuil, 1964).

86. For more on "the task of thought" as the disruption of peace, see Nancy, *Hegel: The Restlessness of the Negative*, 39–40.

87. J. G. Ballard, quoted in Robin Mackay and Armen Avanessian, eds., *#Accelerate: The Acclerationist Reader* (Falmouth: Urbanomic, 2014), 9.

88. Jacques Derrida, "A Certain Impossible Possibility of Saying the Event," trans. Gila Walker, *Critical Inquiry* 33, no. 2 (Winter 2007): 443. Originally published as "Une certaine possibilité impossible de dire l'événement," in *Dire l'événement, est-ce Dire l'événement, est-ce possible?* (Paris: Editions Harmattan, 2001). Regarding the "unconditional" nature of this yes in reference to Emmanuel Levinas, see Jacques Derrida, *Adieu to Emmanuel Levinas*, trans. Pascale-Anne Brault and Michael Naas (Stanford, CA: Stanford University Press, 1999), 13. Originally published as *Adieu à Emmanuel Levinas* (Paris: Galilée, 1997). Badiou also associates the unconditional (or in this case, "unconditioned") with saying yes to another different world: "'Unconditioned' here means that radical emancipatory politics does not set out from an examination of the world that aims to demonstrate its possibility. And also that a

politics is not obliged to present itself as something that represents an objective social grouping. A politics of emancipation draws itself from the void that an event brings forth (fait advent) as the latent inconsistency of the given world. These statements are the naming of this very void." Alain Badiou, *Conditions*, trans. Steven Corcoran (New York: Continuum, 2008), 152. Originally published as *Conditions* (Paris: Editions du Seuil, 1992).

89. It is well known that Deleuze viewed Lucretius and Spinoza as precursors to Nietzsche, who, like him, "conceived philosophy as the power to affirm, as the practical struggle against mystifications, as the expulsion of the negative." Gilles Deleuze, *Pure Immanence*, trans. Anne Boyman (New York: Zone Books, 2001), 84. First published as *Nietzsche* (Paris: PUF, 1965).

90. Correspondingly, Badiou says that "truths occur in making-holes in, in the defection of sense." Badiou, *Conditions*, 165.

91. Jean-Luc Nancy, *The Speculative Remark (One of Hegel's Bons Mots)* (Stanford, CA: Stanford University Press, 2002), 36.

92. Compare Alain Badiou, *Metapolitics*, trans. Jason Barker (London: Verso, 2005), 7. Originally published as *Abrégé de métapolitique* (Paris: Editions du Seuil, 1998): "All resistance is a rupture with what is."

93. In *Minima Moralia*, Adorno writes, "The task of art today is to bring chaos into order" (222). Sloterdijk insists in *Die schrecklichen Kinder der Neuzeit* that order is the exception: "Even those in the tenaciously progressive camp have begun to understand that chaos is the rule to which order represents the most unlikely of exceptions" (87). It would be wrong to assess the two statements as incompatible. The only possibility of holding both in mind is to relate them to each other. Should we call this opening *dialectic*? Why not, as long as it is a dialectic that denies itself the triumph of a final synthesis.

94. On the immanent holes in the dialectical concept, see Slavoj Žižek, *Absolute Recoil* (London: Verso, 2014).

95. F. Scott Fitzgerald, "The Crack-Up," *Esquire*, February 1936, accessed November 7, 2016, http://www.esquire.com/news-politics/a4310/the-crack-up.

96. An event, says Derrida, is "unforeseeable" and "absolutely singular." It "bursts onto my horizon of expectations." Derrida, "A Certain Impossible Possibility of Saying the Event," 446, 441.

97. Jaspers points to the "tendency to eternally go beyond the self, to assert the self again and again in the face of the Absolute" as an attribute of "daemonic existence." Karl Jaspers, *Strindberg and van Gogh*, trans. Oskar Grunow and David Woloshin (Tucson: Arizona University Press, 1977), 11. Originally published as *Strindberg und van Gogh* (1922). Why not take the pathos from this statement by describing contact with the absolute—that is, contact with the untouchable—as the subject's normality? Its normality entails the fact that it remains associated with a void that indicates its ontological inconsistency. Art provides this relation to the unreliable with a form.

98. Alain Badiou, *Logiques des mondes* (Paris: Editions du Seuil, 2006), 570–571; emphasis added.

99. Friedrich Hölderlin, *Hyperion and Selected Poems*, ed. Eric Santner (New York: Continuum, 2002), 157.

100. Foucault, *Remarks on Marx*, 27.

101. Peter Sloterdijk, *Critique of Cynical Reason*, trans. Michael Eldred (Minneapolis: University of Minnesota Press, 1988), xxxiv. Originally published as *Kritik der zynischen Vernunft* (Frankfurt am Main: Suhrkamp, 1983).

102. Compare Kant, *Critique of Pure Reason*, 193–194 (A51/B75): "Thoughts without content are empty, intuitions without concepts are blind."

103. Paul Celan, *The Meridian*, ed. Bernhard Böschenstein and Heino Schmull, trans. Pierre Joris (Stanford, CA: Stanford University Press, 2011), 11. Originally a speech given at the ceremony of the Georg Büchner Prize, October 22, 1960.

104. See Alain Badiou, *Le Séminaire: Lacan. L'antiphilosophie 3, 1994–1995* (Paris: Fayard, 2013), 231.

105. See Alexander Kluge, *In Gefahr und größter Not bringt der Mittelweg den Tod* (Berlin: Vorwerk 8, 1999), 127: "The most strident ideology claims that reality invokes its realistic character."

106. See Giorgio Agamben, "The Passion of Facticity," in *Rethinking Facticity* (Albany: SUNY Press, 2008), 105ff. Originally published as "Die Passion der Faktizität," in *Nymphae* (Berlin: Merve, 2005).

107. Quoted in Deidre Bair, *Samuel Beckett* (New York: Jonathan Cape, 1978), 523.

108. Jacques Derrida, *The Work of Mourning*, ed. and trans. Pascale-Anne Brault and Michael Naas (Chicago: University of Chicago Press, 2001), 48. Originally published as "Les Morts de Roland Barthes," *Poétique* 47 (September 1981): 269–292. Republished in *Psyche* (Paris: Galilée, 1987), 273–304.

109. Jacques Derrida, *Specters of Marx* (New York: Routledge, 1994), 136. Originally published as *Specters de Marx* (Paris: Galilée, 1993).

110. Marguerite Duras, *La vie tranquille* (Paris: Gallimard, 1944), 125.

111. Foucault speaks of the "sacred dimension" of writing, only to immediately assure the reader that it doesn't particularly interest him. See Foucault, *Speech Begins after Death*, 28.

112. Adorno, *Minima Moralia*, 223.

113. Wittgenstein, "A Lecture on Ethics," 12.

114. Conversation between Georges-Arthur Goldschmidt and Reiner Stach, in "Was Kafka am Radschlagen liebte,"

Frankfurter Allgemeine Zeitung, August 23, 2014. No background also means "no curtain hanging in the breeze of another world; no thread pulling the reader to the essence of a hidden reality." Joseph Vogl, *Ort der Gewalt* (Zurich: Diaphanes, 2010), 100.

115. Eva Illouz, *Cold Intimacies: The Making of Emotional Capitalism* (Cambridge, UK: Polity, 2007).

116. Michel Foucault, "What Is Critique?" in *The Politics of Truth*, ed. Sylvère Lotringer, trans. Lysa Hochroth and Catherine Porter (Los Angeles: Semiotext[e], 1997), 42, 25. Originally published as "Qu'est-ce que la critique," *Bulletin de la Société française de philosophy* 84, no. 3 (1990).

117. Duras, *La vie tranquille*, 72.

118. Michelle Porte, *Les Lieux de Marguerite Duras*, film, TF1, 1976.

119. Bernard Stiegler, *Acting Out*, trans. David Barison, Daniel Ross, and Patrick Crogan (Stanford, CA: Stanford University Press, 2009), 3. Originally published as *Passer à l'acte* (Paris: Galilée, 2003).

120. Wittgenstein, *On Certainty*, no. 177.

121. In *La pensée dérobée*, Nancy writes of the "fantastic form of value" (153). Let us add the unreal, fantastic form of love and God.

122. Michel Foucault, "The Anthropological Circle," in *History of Madness*, ed. Jean Khalfa, trans. Jonathan Murphy and Jean Khalfa (New York: Routledge, 2006). This edition is a translation of the French edition titled *Histoire de la Folie à l'âge classique* (Paris: Gallimard, 1972).

123. A quotation by way of Slavoj Žižek, *The Ticklish Subject* (London: Verso, 2000), 274: "Lacan's well-known dictum according to which a madman is not only a beggar who thinks he is a king but also a king who thinks he is a king (i.e. who

perceives his symbolic mandate 'king' as directly grounded in the real of his being)."

124. See Norbert Bolz, "Freimut," *Wer hat Angst vor der Philosophie?* (Munich: Fink, 2012): "Transcendence is the only subversive concept today."

125. Giorgio Agamben, "What Is the Contemporary?" in *What Is an Apparatus?* trans. David Kishik and Stefan Pedatella, (Stanford, CA: Stanford University Press, 2009), 44. Originally published as *Qu'est-ce que le contemporain?* (Paris: Rivages, 2008), 19.

126. Ibid., 45.

127. Compare Hannes Böhringer, *Notlösung* (Berlin: Merve, 2012), 58–59: "Actually the world doesn't exist, it happens, it is constantly collapsing under the weight of events, and I am thrust into this collapse, an expressive interjection, a cry in between." That also means that it stands opposed to a "naked world," to put it in Nancy's words, without solid and ultimately ontological grounds. Nancy, *La pensée dérobée*, 17.

128. Nietzsche's thought interrupts Edmund Husserl's phenomenology before its historical appearance. It is the destruction of the conception of a "primordial ground of meaning." Badiou, *Metapolitics*, 108.

129. From the perspective of the history of science, Foucault insisted on the necessity of comprehending the "historical ground" of "the constitution of scientific knowledge" and our realities. Michel Foucault, "The Stage of Philosophy," in *New York Magazine of Contemporary Art and Philosophy* 1.5, accessed January 1, 2017, https://web.archive.org/web/20110520222341/http://www.ny-magazine.org/PDF/The_Stage_of_Philosophy.html. Originally published as "La scène de la philosophie," in *Dits et écrits III: 1976–1979* (Paris: Gallimard, 1994).

130. Jacques Derrida, *Memoirs of the Blind*, trans. Pascale-Anne Brault and Michael Naas (Chicago: University of Chicago

Press, 1993), 10. Originally published as *Mémoires d'aveugle* (Paris: Réunion des Musées Nationaux, 1991).

131. Jean-Luc Nancy, *Philosophical Chronicles*, trans. Franson Manjali (New York: Fordham University Press, 2008), 38.

132. Theodor W. Adorno, *Negative Dialectics*, trans. E. B. Ashton (London: Routledge, 1973). Originally published as *Negative Dialektik* (Frankfurt am Main: Suhrkamp, 1966).

133. G.W.F. Hegel, *Nürnberger und Heidelberger Schriften 1808–1817* (Frankfurt am Main: Suhrkamp, 1986), 4:163.

134. Nancy, *Hegel: The Restlessness of the Negative*, 23.

135. Ibid.

136. Barthes, *Mythologies*, 152.

137. Ibid.

138. Ibid., 153.

139. Nancy, *Philosophical Chronicles*, 67.

140. Gilles Deleuze, *Essays Critical and Clinical*, trans. Daniel W. Smith and Michael A. Greco (Minneapolis: University of Minnesota Press, 1997), 60.

141. Lacan, *The Seminar of Jacques Lacan*, 76.

142. Nancy, *Hegel: The Restlessness of the Negative*, 40.

143. Jean-Luc Nancy, *Dis-Enclosure: The Deconstruction of Christianity*, trans. Bettina Bergo, Gabriel Malenfant, and Michael B. Smith (New York: Fordham University Press, 2008), 1. Originally published as *Déconstruction du christianisme: Tome 1, La déclosion* (Paris: Editions Galilée, 2005).

144. In *Potentialities*, Agamben also situates reason in this zone of interference between opening and closure: "This is why from its inception, philosophy ... has presented knowledge as caught in a dialectic of memory and oblivion, unconcealment and concealment, alētheia and lēthē" (105).

145. Deleuze, *Pure Immanence*, 89.

146. Ibid.

147. Gilles Deleuze, *Nietzsche and Philosophy*, trans. Hugh Tomlinson (London: Athlone Press, 1983), 110. Originally published as *Nietzsche et la philosophie* (Paris: Presses Universitaires de France, 1962). See also Nancy, *Philosophical Chronicles*, 5: "What was called the 'death of God' and later 'the end of metaphysics,' or even 'the end of philosophy,' consisted in bringing to light the following: there is no first or last condition; there isn't any unconditioned that can be the principle or the origin. But this 'there isn't' isn't unconditioned, and there you have, if I dare say, our 'human condition.'"

148. Martin Heidegger, "What Is Metaphysics?" in *Basic Writings*, ed. David Farrell Krell (Abingdon, UK: Routledge, 1978), 55. Originally "Was ist Metaphysik?" (lecture, University of Freiburg, July 24, 1929).